# FIELD

# FORK

# FASHION

'The idea that fashion is grown and comes from a farm always surprises people as we are so disconnected from where the things we wear come from. So, this wonderful project and book, executed with great charm and creativity, is an *important message*.'
**Anya Hindmarch**

'Alice has conjured a fire inside my belly with her book. I'm pulling out and questioning every garment in my wardrobe, asking myself why it's not made from natural fibres. Her words, her methods and her ideology all have meaning and spirit threaded through them so deeply you can't stop yourself being drawn into her world. The fashion industry better watch out, they have a hurricane coming their way.'
**Zoë Colville, farmer and author of *The Chief Shepherdess***

'Sometimes the best innovation is about looking back to move forward. Alice's work epitomises this concept: the way that she unravels past processes in order to understand how things were made before industrialisation is truly an exploration of what fashion could become, just as much as what fashion was. Fashion should not anymore be just about products, we have too many products and we have lost sight as to how they are made and by whom. Fashion should be about its processes just as much. We should be able to choose what we wear not just because of what it looks like, but because of what it went through. We should choose to wear things of minimum environmental impact and maximum storytelling potential. Fashion should be an exploration of our soil, nature, instincts and capabilities. Alice's work is incredibly original because it takes into account all of the above, from both a creative design and a philosophical perspective.'
**Orsola de Castro, co-founder of Fashion Revolution and author of *Loved Clothes Last***

'Alice's dedication to her art takes her to realms where few artists would go; seeing an animal through its life, building relationships with it, before butchering it and turning each part into something of extraordinary value. At times grotesque, we're nevertheless taken on a journey where it transcends to a thing of pure beauty. We all need to look through her eyes in order to understand what it takes to find a respectable, renewable and sustainable future.'
**Gizzi Erskine, chef, food writer and author of *Restore***

'I consider it an absolute privilege to have first met Alice Robinson a few weeks after she caused a storm feeding the fashion world her sheep. Meeting Malcolm the farmer was the catalyst that such a genuine and driven person needed to connect farming and fashion in a way that can make both industries proud. I'm lucky to count some of the country's most innovative chefs and farmers as friends. I can honestly say Alice will make the most impact with this illustrious bunch. Rebooting the UK leather supply chain is actually a near-impossible task. But by the last page you will, like me, think she just might do it.'
**Matt Chatfield, farmer and founder of The Cornwall Project**

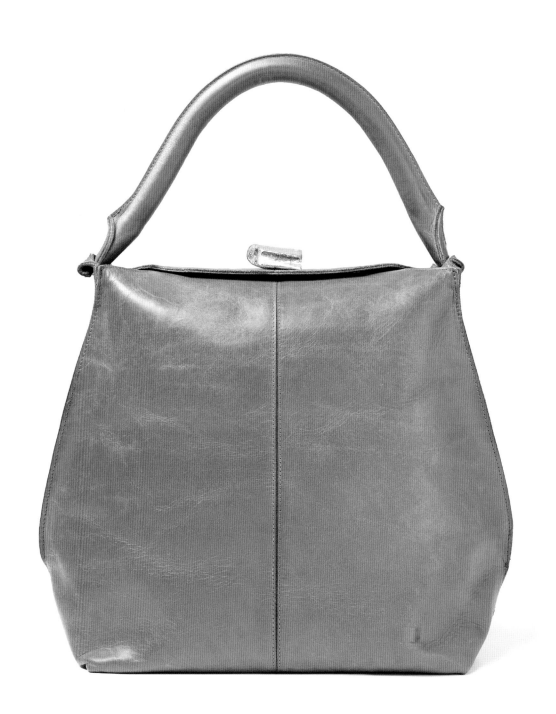

# FIELD

# FORK

# FASHION

Bullock 374 and a designer's journey
to find a future for leather

Alice V Robinson

Chelsea Green Publishing

London, UK

White River Junction, Vermont, US

**For Dad, Mum, Emma and Malcolm – and all aspiring designers trying to make sense of the world.**

Commissioning Editor: Jonathan Rae
Development Editor: Muna Reyal
Project Manager: Vicky Orchard
Copy Editor: Vicky Orchard
Proofreader: Anne Sheasby
Indexer: Vanessa Bird
Page Layout: Glen Wilkins

Printed in the United Kingdom.
First printing in October 2023.
10 9 8 7 6 5 4 3 2 1     23 24 25 26 27

ISBN 978-1-64502-119-3

Our Commitment to Green Publishing
Chelsea Green sees publishing as a tool for cultural change and ecological stewardship. We strive to align our book manufacturing practices with our editorial mission and to reduce the impact of our business enterprise in the environment. We print our books and catalogues on chlorine-free recycled paper, using vegetable-based inks whenever possible. *Field, Fork, Fashion* was printed and bound in Great Britain by Bell & Bain Ltd, Glasgow.

Chelsea Green Publishing
London, UK
White River Junction, Vermont USA

www.chelseagreen.co.uk

# CONTENTS

# FROM FASHION TO FIELD

In the beginning, I just wanted to make a handbag. But, after questioning what connections this simple item could hold, I became aware that I needed to see the bigger picture. So, on 9 October 2018, I bought a bullock.

Fashion is dependent on agriculture, and luxury fashion is especially so. From fields of cotton to wool, cashmere and silk, some of fashion's most coveted materials are derived from a farmed natural resource. In the case of leather, it begins as the skin of an animal that (with the exception of exotics) has been reared for food by a global meat industry. This inescapable link to animal agriculture, and the associated negative impacts on animal welfare and the environment, contribute to leather being one of the most controversial materials used in fashion today.

When I was studying for a degree in accessory design, leather was the most prevalent material used in the sector many of us endeavoured to become a part of. Working with leather hadn't been a requirement, it was more of a logical assumption that we would choose it.

*COLLECTION 374 BELTED SUEDE COAT*

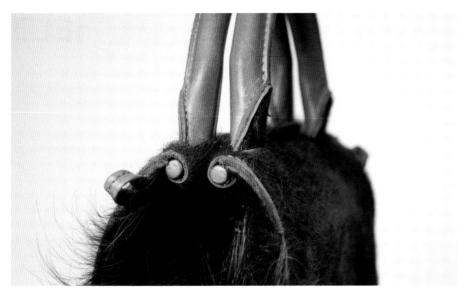

COLLECTION 374 SMALL HAIR-ON HANDBAG

Leather's famed attributes in terms of beauty, durability and versatility are unparalleled. For all those reasons it was the material of choice for the high-quality accessories I intended to design. But, as I began to consider its use, I found myself asking questions, starting with: 'Where has it come from?'

I grew up in Shropshire, the daughter of a farm vet. I had been privileged to live alongside farmers and to experience the animals and places that produce our food. This exposure influenced what I chose to eat. Until I started working with leather, however, I had seen no relationship between my upbringing and my interests in fashion.

Such a relationship did not exist in leather, but I knew there must be a story to tell. The material's connection to agriculture provided me with an opportunity to move from working as a designer in my own silo to learning from a local nature-friendly farmer. By looking beyond the cultural capital of leather goods, and the value bestowed upon them by a brand, I hoped to see instead how the interests of fashion intersected with those of food and farming.

This book is the story of my efforts to explore the reasons for leather's lack of traceability to the type of agriculture it came from, to understand what such a relationship could mean for design, sustainability and fashion systems – and ultimately to reconnect fashion with farming.

9

# HOW I GOT THERE

I fell in love with designing and making clothing long before I began to ask questions about the impact of the fashion industry. I applied to the London College of Fashion's FdA Designer Pattern Cutting course because, as I understand now, it was not so much the creation of items deemed 'fashion' that I enjoyed, but the act of transformation from cloth to a 3D form that provides protection, identity, confidence, joy.

A year into my BA degree in Womenswear at Edinburgh University, I had the opportunity to move to Scandinavia for the summer and work at an international brand for three months. It was an illuminating experience, seeing at first-hand how the 'fast' stream of fashion operated. With sharp focus, we would sift through the most recent catwalk shows. Our job was to react quickly and bring these new and emerging trends from the few to the masses. The scale of the company was unlike anything I'd ever comprehended, despite having been a loyal customer for years.

Overproduction, excessive consumption and the externalising of true costs in fashion weren't things I thought deeply about until I was prompted to do so during my Master's degree in Womenswear Accessories at the Royal College of Art. This degree introduced me to new and challenging conversations about fashion and our head of programme, Zowie Broach, nurtured and encouraged us to find new ways of thinking. In our cohort of 55 students, we discussed where we felt conflicted and motivated to respond to the industry as it was. And for two years we had the freedom to explore, make mistakes and be radical with our concepts.

During that time we were encouraged to question everything, to consider the systemic issues of the industry and to suggest new ways of thinking to address them. We were encouraged to be hopeful, to use fashion and design as the tool for which it always has been, an embodiment of culture, craft and connectivity. And to think about how the future landscape of fashion would look through these lenses.

# A MATERIAL CHANGE

Moving from a BA to an MA had also brought with it a change in focus for me, from pattern cutting and material development of shirts, coats, trousers and dresses, to a specialism in accessories, focusing on bags, belts, wallets and the like. This had taken me, in a literal sense, from a materials closet of cottons, silks, linens, viscose and polyester-blends to a storeroom at the RCA of hardware fittings, grey board, rope, glue and roll upon roll of leather.

Every type of leather that you could imagine was stacked on shelves in bundles: thick and supple to paper-thin and parchment-like, and in a wide-ranging palette of colours. Printed, fluorescent, embossed and debossed, snakeskin patterns and false grains. There was full fleece, short hair, soft fur and scales.

New terminology was introduced to me: full grain, corrected grain, genuine leather, split leather, sole leather, suede, nappa, veg-tan, chrome, crust, aniline, semi-aniline, pigmented and nubuck. From a creative perspective, what lay inside that store cupboard provided infinite inspiration. Here was a material that seemed to have few limitations in its performance capabilities and an unending capacity for transformation.

This first year introduced me to a material that I'd encountered my whole life, yet one I had given very little thought to. Only as I began to work with leather as a designer, did I begin to see it differently.

Unlike the woven textiles in our store cupboards, leather did not come with a composition breakdown. For that we had independent leatherworker Stephanie Freude, our magnificent technician. Pulling snippets and taking swatches from the rolls of possibility before me, I would ask: 'What is this?'

Many of the answers were straightforward. If a piece was really thick, say more than 3mm, then it must have come from a large animal. If it were thin, around 0.5mm, then it was more likely to have come from a smaller animal. As hides and skins are derived from animal agriculture, we could deduce that the leathers belonged to one of the four main species raised for meat or dairy around the world: cattle, sheep, goats or pigs.

11

I was introduced to new terminology; words such as bovine, ovine, caprine, hides and skins. When the animal origins could not easily be discerned, I learned to look for tell-tale signs to guide my enquiries. Leather that had been produced

from pigskin, for instance, will often still have perforation marks where thick hairs once sprouted – although the skins might be similar in size to that of a sheep or a goat, the hairs on those are much finer and therefore the holes are less detectable in finished leather. The guessing game gets harder as pattern pieces are cut out from a whole hide or skin.

Spreading them out on the pattern-cutting table, I began to learn how to collect information that would give me more of an image of the animal. This was easier for the smaller skins, as they were usually uncut. I could see that the two protrusions on either of the longer sides were where the front and back legs had been. And an extension at the shorter end of the skin could be identified as the neck. If the leather had not been too heavily coated in a pigment finish, then a faint shadow and denser grain down the centre of the skin would denote the direction the spine had run. Scrunching the leather between my fingers and pulling from the spine back towards the belly, I could feel how the structure of the skin changed, from being tighter in the centre at the spine, then gradually becoming looser towards the belly. Throughout, fluidities that reflected the movement of the animal's body were evident in the leather. It was impossible, I found, not to confront leather's ingenuity without facing its innate animality.

Unlike the materials I'd worked with before, leather didn't come by the roll. It did not have a warp and weft, and deciding where to place pattern pieces did not depend on whether I wanted to avoid cutting on the bias or not. My design decisions were impacted by the reality that leather comes from an animal and, as with all things natural, nothing is identical. Designing with leather meant gaining an understanding of different animal species. Each part of the body had its own structure, which would therefore affect where I would place my designs – did I need stretch, did I need tightness, did I need somewhere in between? In addition to considering placement, I learned that not all types of leather perform the same way either. For instance, leather made from a cattle hide will make a durable seat in an aeroplane, but not provide you with silky soft gloves to fly it, for those you'd want a sheep. More specifically, you'd want a sheep breed that grows a greater ratio of hair fibres to wool fibres because numerous fine wool fibres will break up the skin structure, and this provides maximum fluidity.

Still, acknowledging the raw materials' animal origins was only half of the education I needed.

# LEATHER BEGINS AT A TANNERY

Six months into our Master's degree course, many of us had just begun working with leather for the first time, so we travelled to the Institute of Creative Leather Technology, the micro-tannery on the campus of Northampton University, one of a kind in the UK and one of only a few throughout Europe. The trip was to introduce us to some of the processes behind making the material.

Our morning was spent in a classroom where we engaged in leather chemistry for beginners and, in the afternoon, we were immersed in the tannery, playing with colour, texture and temper (the suppleness or stiffness of the material). I witnessed three pieces of leather cut from the same hide go through individual transformations. With small changes in application each morphed to become entirely distinct. One application of a gloss fired through the spray gun gave a piece a high shine reflective surface, another sprayed dye that brought consistency to the colour, and the third went through a revolving piece of sandpaper which resulted in a nap as soft as icing sugar.

The day had begun with an explanation of the historic methods of creating leather, first with the use of oils, barks and leaves to more modern innovations of salts, minerals and synthetic tannins. We were given an education in the array of techniques used to transform degradable raw materials – hides and

skins – into adaptable and alluring leathers. Each of us donned lab coats, protective glasses and wellies to see skins sloshing around in drums filled with ingredients that had been chosen to enhance or improve performance in the finished materials. I realised that this work combined technical skills with intellect, an appreciation of craft and a deep respect for the biological ingenuity of a natural fibre.

Thanks to advancements in leather chemistry and novel approaches of applying it, the opportunities to innovate and manipulate are near limitless. I learned that while the origins of the raw material dictated qualities in the leather to an extent, there were still innumerable possibilities for how the material could eventually look and perform when applied in designs. Accompanying these different levels of intervention and chemical manipulation, which could also give uniformity and standardisation to this natural material, there were degrees of sustainability to consider as well.

But the most immediate question on my mind at this point was sourcing. Where did this material come from? And how would understanding its provenance direct my design decisions?

*SATTLED CATTLE HIDES AT A TANNERY IN ITALY*

# LOOKING FOR A CONNECTION

I began to visit leather merchants, asking questions whenever I could about the origins of these materials. In doing so I began to understand the global and complex picture of leather production.

First, hides and skins are collected in a raw state from an abattoir. They are sorted, preserved and accumulated in large volumes. They can then be moved, sometimes from country to country or even continent to continent, during three main stages: either as a raw material, when part processed or as finished leather.

Leather-making businesses often specialise in producing a particular type of finished material, for example, sheep shearling or shoe soles. As the raw material needed to create that type of leather may not be locally available or in the volumes necessary, they must purchase it from large globalised supply chains.

For example, the United States and Brazil produce the largest quantities of beef globally. While the USA is the largest global producer of beef, it is also a leading exporter of hides and, as a consequence, not the highest producer of leather. China, however, is the third largest producer of beef in the world, while Italy is only the third largest in Europe. Despite this, both countries' tanning and manufacturing capacities exceed their domestic supply of raw materials and therefore rely on imports from countries such as the USA to provide them with greater volumes. These imports then enable China and Italy to be some of highest producers of finished leather globally.

Throughout the whole transformation from raw to finished leather, ownership of the material can change hands multiple times before reaching the designer. While a hide may have come from an animal in one country, the leather it produces may have been created in another. I began to realise that asking from where this material originated was far from straightforward to answer.

Instead, what became clear was that the success of this global trade is in part due to the intrinsic versatility of these abundant raw materials. And yet, despite this, not all hides are turned into leather. Estimates suggest that globally 45 per cent of hides are going to waste, with over 5 million cattle hides produced in America unaccounted for in the leather value chain. Along the journey from farm to abattoir to finished leather, the material's value transitioned. From a fundamental essential to life, a raw material and tradable commodity, to a finished material crafted by the leather industry.

15

*SIGNS OF SHEEP GRAZING, SHROPSHIRE – SOURCE OF COLLECTION 11458*

So I started to look for information beyond the name of the tannery. Beyond the country or region that they bought their raw materials from. What food, and therefore agricultural, system had these hides been a part of?

My dad's job as a vet in a rural community meant that when I was growing up we had an awareness of where our food came from. Occasionally, we'd experience a reward for his work – a gift of a joint of beef or mutton from a farmer. Access to food produced locally came with a connection to the farm and this connection was imbued with value; it influenced the buying decisions we made. Looking at all of the leathers in front of me, I wondered about this missing link, and what stories had been lost? And if that story could be shared, what sort of relationship would it reveal between our food and clothing?

These questions prompted me to consider leather from this perspective.

# WHAT IS BEAUTY?

For two years, my commute to the Royal College of Art involved travelling through one of the most opulent streets in London, Sloane Avenue. Twice a day, my journey provided a sumptuous encounter with luxury fashion's finest. Sitting on the top deck of the bus, where I could get the best view, I'd snoop through the window and appreciate the bags on top of polished glass cabinets. Each brand's name debossed or engraved on stunning craftsmanship stated its claim.

Many of the leathers behind the shop windows were impervious. Glossy coatings hid any evidence of imperfection. Multiples of the same design sat in stores on every continent, each providing identical offerings. These pieces are seen as the pinnacle of luxury fashion, but what set them apart? I began imagining that they were interchangeable. Laid out on an assembly line before the brand name was added or label stitched in. What had come before their adopted identity?

I began to wonder about these items, viewing them not as products of the brand but as an extension of something else: agriculture. What was this story and how could it be framed, presented... and valued?

Informed by the knowledge that leather originated in food systems, I aimed to explore how that connection could influence my work as a designer. I decided that in order to find answers to my questions, I'd need to follow it as a product from the field and confront its transformation into food and fibre.

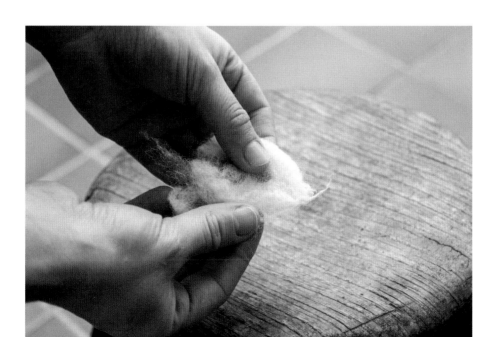

# SHEEP 11458

This decision led me to return to the Institute of Creative Leather Technology later in the year with a sheepskin that I had sourced from a farm near my home.

Overseeing the micro-tannery was David Sherwood. After decades in the industry his knowledge of the material was invaluable, as was his generosity in sharing it. David used traditional techniques to remove the wool from the skin; skills that are no longer practised at scale in Britain but would have historically been carried out by someone called a fellmonger. The micro-tannery mimicked the sophistications of modern commercial tanneries, but its small drums and low throughputs meant that I could request what ingredients could be used in the tanning process. Crucially, the facility and David ensured that I would receive the fleece and leather from that sheepskin, enabling me to work with materials with origins I could trace, rather than an anonymous finished product.

Once stripped from the skin, a full fleece remained. With no knowledge of how to turn this from a mat of dirty fibres into something that resembled

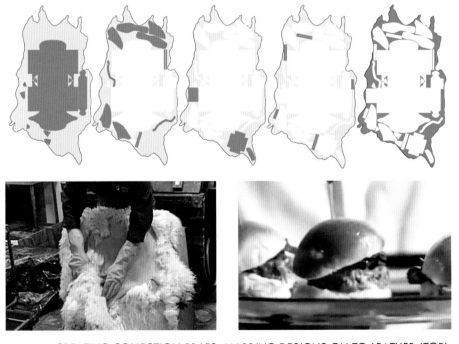

*CREATING COLLECTION 11458: MAPPING DESIGNS ON TO LEATHER (TOP);*
*REMOVING THE WOOL FROM THE SKIN (LEFT);*
*BURGERS CREATED FROM THE MINCED MEAT (RIGHT)*

yarn, I was encouraged to go to a spinning class run by a skilled artisan, Jessica Mason. Taking a punt, I told Jessica about my project. Playing with the small clump I'd brought with me, she pulled the soft fibres apart. The staple was long enough, she thought. But it would be time-consuming to spin the whole fleece on a drop spindle, as I had naively intended. Not knowing what these things meant I nodded along. She suggested using her grandmother's wooden spinning wheel and, over the course of several months, Jessica turned the fleece from a tangled mat into spools of creamy 2-ply yarn suitable for knitting.

The skin, in the meantime, was treated with natural tannins from tree barks, producing supple biscuit-coloured leather. Together, the wool and leather represented the natural fibres that came from this one sheep and formed the basis of my Master's degree fashion collection.

From these materials, I created five items: a jumper, a pair of gloves, a bag, a pair of shoes and a purse. Designing the collection had been a challenge. The materials produced from sheep 11458 were imperfect and finite. The aesthetic of the work was defined by that fact. The fibre qualities of the wool and skin were a result of the sheep breed, a breed that had been chosen by a farmer to be suitable for their farm business, rather than my designs.

But it had been an opportunity to work with a material that was tied to communities that were producing food and stewarding land. Describing leather as a 'by-product of the meat industry' was not enough for me. What would it look like to work, from start to finish, with natural materials that came from the land around me?

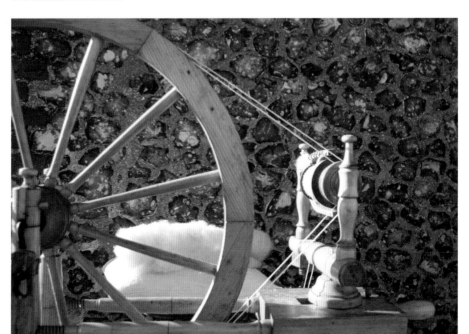

# FOOD: BIGGER THAN THE PLATE

'They'd like me to bring Collection 11458 to London and talk about an upcoming exhibition', I shouted out to my mum. It was the summer of 2018 and I'd just graduated from the RCA (Royal College of Art).

I gestured to my laptop, flushed and inaudible. An email from the Victoria & Albert Museum was open on the screen.

The exhibition that they were curating would come to be called FOOD: Bigger than the Plate and they saw an opportunity for Collection 11458 to have a place in the 'Waste' section of the exhibit.

Without hesitation, I dashed out a reply saying I could be on the first train to visit at their earliest convenience. A couple of days later I set off, clutching in my arms the box containing the work I'd spent the previous year creating for my degree.

Propped up next to the items was a file with nine books in it. Book number one showed the farm in Shropshire where the materials inside the box had originated. The other short books chronicled my year of learning what this one sheep, a cross between a Texel ram and Welsh mule, represented in terms of food and fashion. The entries documented each stage, from preserving the skin to butchering the carcass, to finding a way to spin the fleece and create leather.

The books described my reflections on how I felt about being involved in this whole process and the sense of responsibility it gave me. It had been the sense of connection I'd been looking for.

I remember kneeling on the lawn in the central courtyard of the Victoria & Albert Museum and talking through the collection with the curators. As I lifted the thickly rimmed white lid, I first handed them an A4 piece of paper with a photo on it.

The picture was of one of the 350 burgers (see page 18) made by renowned chef Margot Henderson from the minced meat of the sheep. These had been eaten a few months earlier during a presentation at our MA degree show. As the audience had faced me, mic'd up Britney-style in front of a fifteen-foot image of a Shropshire field (see page 16), waiters had formed an arc around the crowd. As I finished speaking, the audience were invited to turn to taste the burgers.

11458

SY12OJZ

# FINDING PROVENANCE

I showed the curators this photo first because this was the topic I was there to discuss: food. Searching for leather that could provide me with knowledge of its connection to food and farming had been the beginning of my research.

And what I had found was that, at that time, it had been impossible. Searching leather wholesalers and online, I received partial answers as to where these materials had originated. Opaque and fragmented supply chains made traceability a challenge. As a raw material, hides and skins used to make leather were abundant but of little value. Economies of scale prevailed in this industry and there was no way for me to trace a material backwards to the field the animal had belonged to. Somewhere along the chain, that connection gets lost. Understanding this motivated me to learn more.

The year's project had culminated in the items within that box, but the research that led to them had been exploring something broader: the relationship between leather used in fashion and its connection to food and agriculture. I wanted to ask questions of myself, and of the fashion industry more broadly, about how these materials were valued by us.

Since returning home after university, my interest in leather had given the fields around me renewed significance. I was lucky to be living in a part of the world where pasture-based animal agriculture is prevalent. The raw material needed to create leather originates in those fields. I reasoned that I should start there.

My interests in the material forced me to step out of the studio and led me to find a more complete picture of how and where the raw material to produce leather originated. So, when I met the curators at the V&A, I told them about a man called Malcolm Adams. A farmer I'd met just a few weeks prior. He'd been producing food from his 80-acre farm for his local community for the last 40 years. He would be taking three of his cattle to an abattoir in the coming months, two he'd already sold to a butcher and promised to loyal customers. We'd discussed that I could purchase the third, a Longhorn Limousin cross.

I'd started small with my first project, looking at the materials that came from one sheep from one farm close to me. The reality was that I needed to confront a much greater challenge. As an accessories designer, the leather I'd most often encounter comes from cattle.

The eventual information a leather product holds can be gathered from four stages: the farm, abattoir, tanning and making. I would follow those stages to see what leather could be produced from the hide of a single bullock from a local farmer and therefore what fashion could be created from it.

Different stages depended on factors pertaining to different industries. The time of year Malcolm needed to take his cattle to the abattoir. The length of time tanning would take in Britain. The resulting look of the leather would be determined by choices made at every stage, but fundamentally and uniquely by this particular bullock.

The exhibition opened in eight months' time. At that point, I couldn't tell them what would be shown. How many items, their sizes, what they'd look like – everything was unknown.

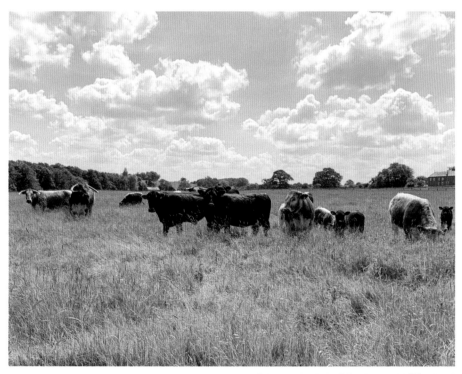

*CATTLE AT MALCOLM ADAMS'S FARM*

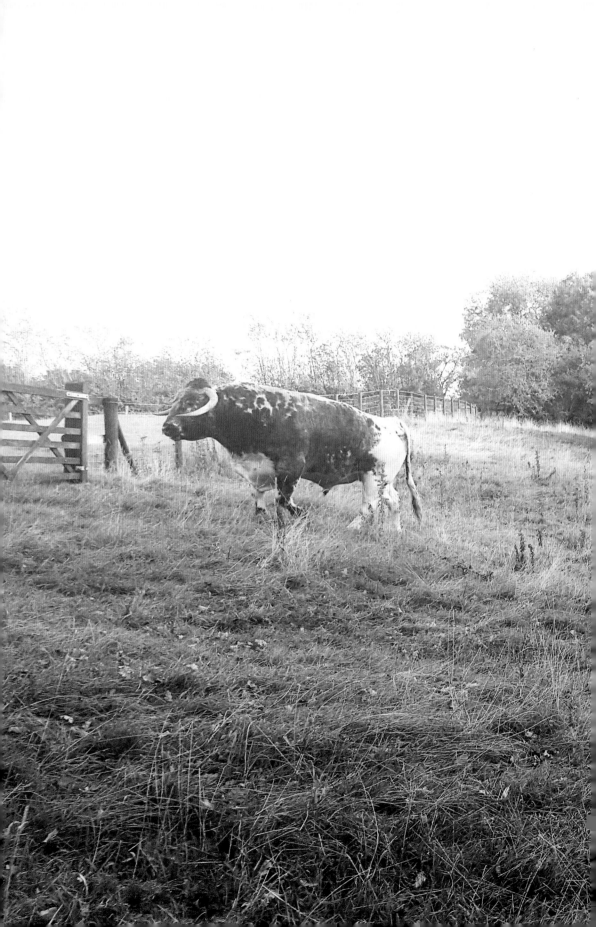

# CHAPTER 1
# MEETING MALCOLM

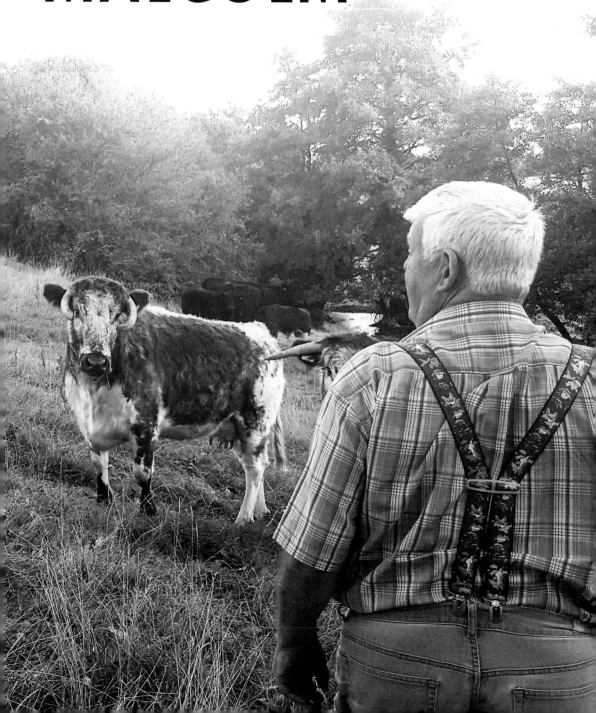

From humble beginnings in the forms of shelter and protection for our newly hairless ancestors, leather has transformed into a multi-billion pound global industry, the majority of which today is used in fashion.

Once I began questioning the origins of modern leather, I realised I had no idea about the story behind it. All I did know was that it begins on a farm. There, decisions on how food is produced and how land is used to do so are made. Our food system shapes these choices; external influences and market pressures guide actions that impact land, animal health, biodiversity, ecosystems and communities.

My earliest understanding of farming was formed through the lens of my dad's profession as a farm vet. Despite the fact that there is no shortage of opportunities to visit farms, with over two thirds of the land in Britain used for agriculture, it was his stories and work that brought to life the people and animals I saw from a distance. So, when I began to have questions about fashion's connection to farming, our home in Shropshire was the place I went to seek answers.

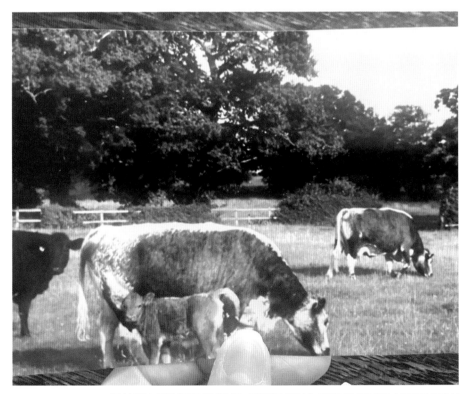

*NANCY (CENTRE FRONT), THREE-YEAR-OLD ENGLISH LONGHORN*

*MY DAD AND UNCLE'S HERD AT THEIR SMALLHOLDING*

The location of our family home was chosen for its proximity to Dad's clients. We grew up sharing him with the farming community. The squawk of his chunky work telephone, the sort with large punch-in numbers and a springy cable, would ring throughout our house, day and night, on Christmas Eve, Easter and birthdays. My bedroom windows overlooked the driveway, so I'd hear Dad's swift response to call-outs. Boots meeting tarmac, metal springs creaking open and clanging closed, a thud, then his car trailing away.

On occasions, he'd come home after a long day with a swollen arm or leg, ruddy with bruises indistinguishable from mud and grime, souvenirs from a successful day of TB testing. The car was always heavy with the scent of black ice air freshener that could never quite defeat the smell of muck and medicine and instead amalgamated into its own eau de vet. Moss-coloured synthetic seat covers, an essential part of the uniform, acted as a concealer for what the Volvo had really seen. Sometimes our school pick-ups would get doubled up with a call-out. We'd wind up into the hills, me in the passenger seat, my little feet kicked out on the dashboard, still in my hockey kit.

27

# A HEIFER OF ONE'S OWN

It was a personal desire of Dad's to own cattle. Animals he could visit regardless of ailment or impending emergency. In 2005, the opportunity arose for a joint venture with my uncle, who had some acres of grass that he wanted to manage by grazing cattle. Dad had inherited a small sum of money, enough to buy one heifer. This happened around the same time I was discovering my own passion: making clothes. I was 14 and finding my stride on the sewing machine when Dad bought Nancy, a three-year-old English Longhorn (see page 26). She would be the beginning of a small herd that would live at my uncle's holding.

The choice of breed was threefold. The English Longhorn is a breed of cattle native to Britain with an ancestry intertwined with agricultural progression. Their popularity as a breed has peaked and plummeted throughout their long history in the fields of the northern English counties, where their presence has been noted since medieval times. Like many native breeds, they are famed for their hardiness and a high tolerance for sustaining a life outdoors. With the ability to thrive off relatively poor grassland vegetation and forage, they are a good choice for grazing on land that is otherwise deemed unproductive for producing food.

However, like many other traditional breeds, the popularity of the Longhorn declined in the 1800s when farming began to focus on cattle breeds with specialised traits. The Longhorn was first superseded by the improved Shorthorn, then later by cattle without horns, which were faster growing, produced greater yields of beef and milk and were housed indoors, meaning they didn't graze or forage, but grew fast on a diet of cereals and corn.

The English Longhorn, which prospered in a natural environment, no longer aligned with the economic pressures of modern farming, and the breed declined such that in 1980 it became a breed of interest to the Rare Breeds Survival Trust, whose work rescued it from further decline.

For hobbyist farmers such as my dad and uncle, the Longhorn's attributes that had contributed to its pre-industrial popularity were exactly what appealed to them, along with one of their most notable characteristics, their appearance. 'They are beautiful to look at', my uncle recalled when I asked why Longhorns. English Longhorns are famed for their looks. As the name suggests, they are recognised for their striking horns that most often grow downwards towards the nose, framing the face. Were it not for their docile nature, they may have seemed

much more imposing. I've wondered if this quality might be attributed to an innate feeling of belonging on this land.

Their coats are a brindled pattern and range from dark hazelnut reds to caramel browns, with a hereditary white strip (called 'finching') down the spine. Dapples of white break up this colouring and, in the sun, some almost look tiger-striped. The whole effect makes them look ancient and magnificent.

The arrangement between my dad and uncle was simple. One provided the grass and the other the veterinary assistance. Together, they sold the yearlings on for meat to local restaurants interested in native breeds and kept the heifers for breeding. The cattle's presence at the holding stimulated the growth of plants, and their dung, hair and hooves helped to distribute the seeds they'd eaten. Once they arrived in our lives, visits were joyously added to journeys home.

The matriarchy grew to three in summer 2009 when Violet gave birth to Doris. Her entry into the world gave everyone a fright. She was born weak and needed nursing to get her through her first few days. Dad, who had endured plenty of sleepless nights in order to save the lives of local animals, fed her through a tube and willed her to live. Thankfully, Doris was a fighter, born of good stock with a genetic predisposition to prosper. She was the last to be born at the holding, as a few months after her arrival the herd was sold to a local farmer.

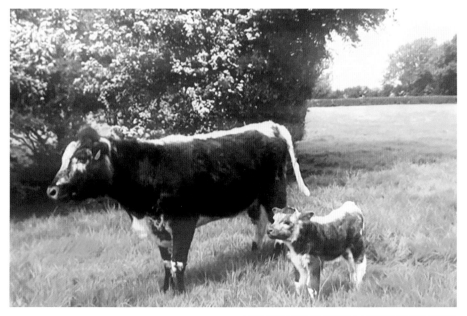

*VIOLET, THE ENGLISH LONGHORN (LEFT)*

SPECIES-RICH PASTURE AT CHARITY FARM

# COMING HOME

Approximately two thirds of global leather production is made from the hides of cattle. It was leather made from the hides of cattle that created many of the bags framed in glistening shop windows in London. Its use is popular in accessory design because of its thickness and versatility, while the scale of global beef production means it is also accessible and abundant.

I wanted to continue my exploration into the leather industry, this time from cattle, but the scale of leather production was intimidating. In Britain alone, 50,000 cattle are taken to abattoirs each week, and globally, an estimated 300 million are slaughtered every year.

Leaving this complexity aside, even if I could trace a hide back to its origins, I couldn't be sure I'd find what I was looking for; a connection to agriculture that was nature friendly, with high animal welfare. A material from a system that was fair to farmers, enabled resilient and nutritious food production and supported rural economies.

I wanted to treat this material in a way that supported the principles of the food system it came from, but the challenge I faced was that the raw materials are not defined by the agriculture they came from. Hides and skins are viewed as 'by-products' of the meat and dairy industry and all coalesce anonymously under that umbrella.

So, to learn how my design practice connected to agriculture, I'd need to actually start from the farm. Asking where leather comes from had led me back to my own origins with food producers and land stewards.

I shared my interest with my family. Fortunately for me, three of my dad's four sisters had married men either in farming or agriculturally adjacent professions, and thanks to the mass of farmland between Shropshire, Cheshire and North Wales, they all remained living close by. Therefore my musings about cattle did not fall on disinterested ears.

'You should meet Malcolm', said my uncle. If I wanted to know more about that type of farming, he suggested there was no better person to learn from. On top of that, 'he has your dad's cows'.

# CHARITY FARM

This conversation brought on a sudden jolt of memory. Malcolm Adams, a local farmer in Halghton. I'd heard his name but we'd never met.

He was the third generation to produce food from the fields of his farm. Before then his family had lived down the road, and if they had stayed farming there, he would have been approximately the tenth generation to do so. If I were to learn from anyone, it would be him.

Beyond the market town of Ellesmere, where I grew up, is a protrusion of Welsh countryside and nestled within it is Malcolm's farm. My uncle and I pulled up, just after midday. A sign hanging perfectly at shoulder height read CHARITY FARM in bold white capital letters. It was the first thing I saw from inside the truck as we turned into a yard to meet Malcolm.

After introductions, he joined us in the truck and we set off in search of his herd. Directing from the front seat as we entered the first field, Malcolm helped my uncle navigate the cambers hidden within the tall perennial grass. Despite its length, he knew the ground beneath us by

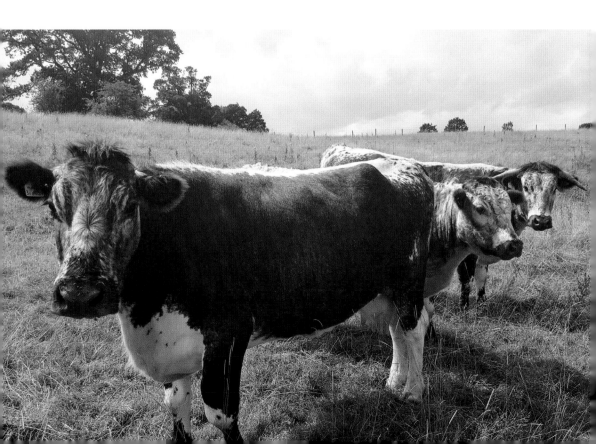

memory. The field we were in was filled with native meadow grasses, containing wildflowers like yellow rattle and bird's-foot trefoil. And, despite the months of scorching summer sun, the earth remained covered and cool. The field itself had never been ploughed due to its terrain and soil quality, which meant that it was unsuitable for growing crops but perfect for growing grass.

We approached a flattened plain near the end of the field and I saw horned heads begin to rise, curious about our approach but not startled by it.

'There they are', said Malcolm. He began to point out members of the herd; the newest additions, calves only a couple of months old standing close to their mothers and then, sashaying through the rushes, came Violet.

My uncle flicked through the pages of his old cattle logbook. He'd highlighted in yellow the heifers that had belonged to Dad. The book contained information on the age, breed, sex and sire and dam of the cattle. Violet continued to walk towards us as we tried to work out her age. She'd been the first Longhorn heifer of my dad's born at the smallholding 13 years earlier. 'Ah yes, she's going well', said Malcolm.

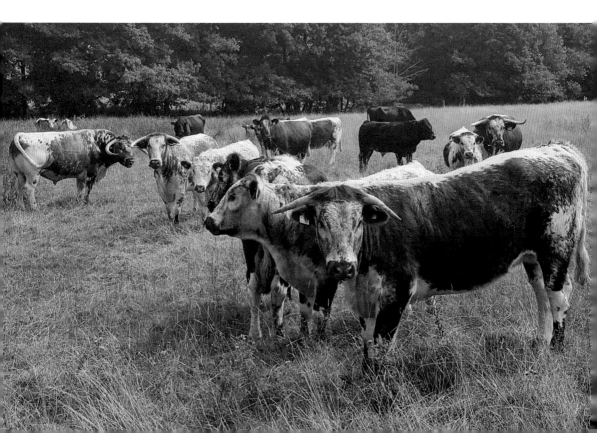

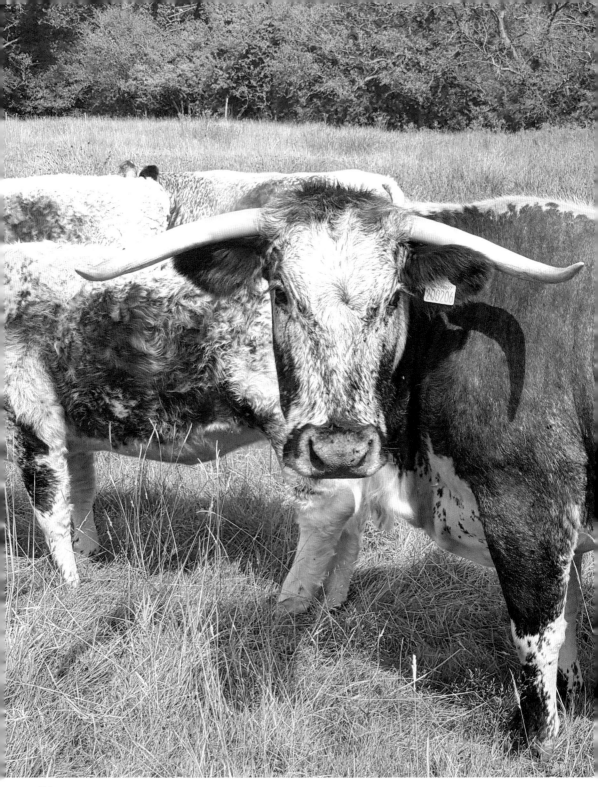

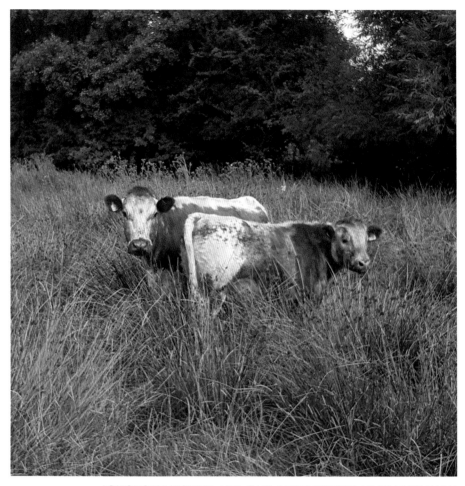

*LONGHORN MOTHER AND CALF IN THE RUSHES AT CHARITY FARM*

Another highlighted name in my uncle's logbook was Doris. The calf that made it through the night, she was now ten and was using her tongue to strip a willow tree of its leaves. Behind her was a stream, dividing the field we were in with the next. On the opposite bank were alder, poplar and black poplar trees, some mature and others newly established, planted by Malcolm with his wife Annie and groups of volunteers over the years. Standing next to Doris, looking at us, was a heifer with horns looping straight towards her head. Their direction of travel was directly into her temples, a Princess Leia of Longhorns.

We continued our tour and found the herd dispersed in pockets throughout the field. Lining the perimeter were hawthorn hedgerows full of mature oak and ash and within them, every so often, towered trees offering pools of shade. The hedgerows from the stream to the roadside acted as corridors for wildlife.

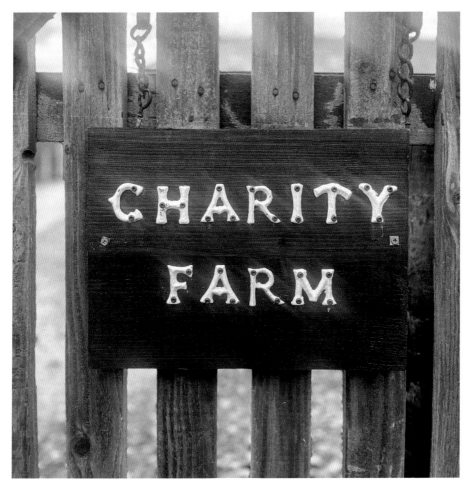

THE SIGN WELCOMING YOU TO CHARITY FARM

A crèche of mothers and their calves, this time of a different breed, had nestled near to the entrance of the field. Malcolm had both an English Longhorn and a Limousin bull on the farm. These calves were either pure caramel colour or pure black.

We reached the final group. 'These are all steers, bullocks', Malcolm tells us. They're more boisterous than the others and are intrigued by the truck. Malcolm is explaining the breeding of each as they continue to move closer, causing the truck sensors to beep in warning. It feels as if we've reached the breakaway rebels. A few were approaching the 30-month age, and soon he would be taking them to the abattoir.

# FARMING WITH NATURE

There is a preservation order on one of the oaks that has seen the three generations of Adams's work in the fields of Charity Farm. It is estimated to be 350 years old, 18ft 6in girth. 'It's a hell of a tree', Malcolm tells me.

We are now in the farmhouse. Pictures of cows and sheep hang on the walls, pencil drawings of favourite lambs and prize-winning Longhorns, first-place rosettes clipped onto frames displaying conservation awards. I catch a glimpse of the farm's rich history while still standing on the welcome mat.

Malcolm hands me black and white photographs dating from 1954. The name John Adams runs across a sign nailed to the slats of the wooden cart where a young Malcolm sits inside. He can't be much taller than the spokes of the wheels that are being turned by the beautiful horse in front.

In another image, 'The Gaffer', Malcolm's grandfather John Adams, sits with a pipe jutting from his mouth. His sleeves are rolled to his elbows that rest on his thighs; broad legs anchor him and between them large hands are clasped in thought. 'A gentle giant', Malcolm tells me. He'd regarded him as a father and it was John who taught him how to farm on Halghton Lane.

Adams's have farmed in Halghton since the 1600s. From then on, Adams's have produced food from the fields I am surrounded by. As a young boy, Malcolm's grandfather ran Charity Farm while his dad converted the old paper mill into a corn mill. Being part of local food production is in Malcolm's DNA, and doing so with nature in mind is a skill which was passed down to him.

In The Gaffer's era, the farm kept native Shorthorn cattle, two or three sows (pigs) and lots of poultry, including 200–300 chickens. In hen pens and in lofts there were 20 geese and 30 turkeys for Christmas. And he always had ducks and cockerels, about 50 of each.

Some fields on the farm operated on a three-year crop rotation. 'Everybody did it.' Growing fields of corn, turnips and grass, alternating each year. One field for food, one for feed and one for resting. Rotation kept the soil healthy as each crop required different nutrients. During the rest period, grass grew and the cattle would graze and fertilise it before the cycle began again. The rich milk produced was then taken to Ellesmere and made into cheese.

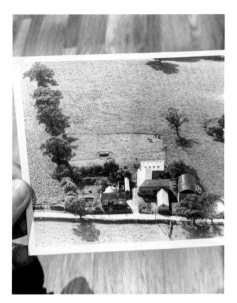

AERIAL VIEW OF CHARITY FARM
IN THE 1960S

MALCOLM'S DAD AND FRIEND DAN
DAVIES IN THE EARLY 1970S

CHAROLAIS BULLOCK AT THE FARM
IN THE 1960S

EILEEN ADAMS, MALCOLM'S MOTHER,
CUTTING CORN, 1947

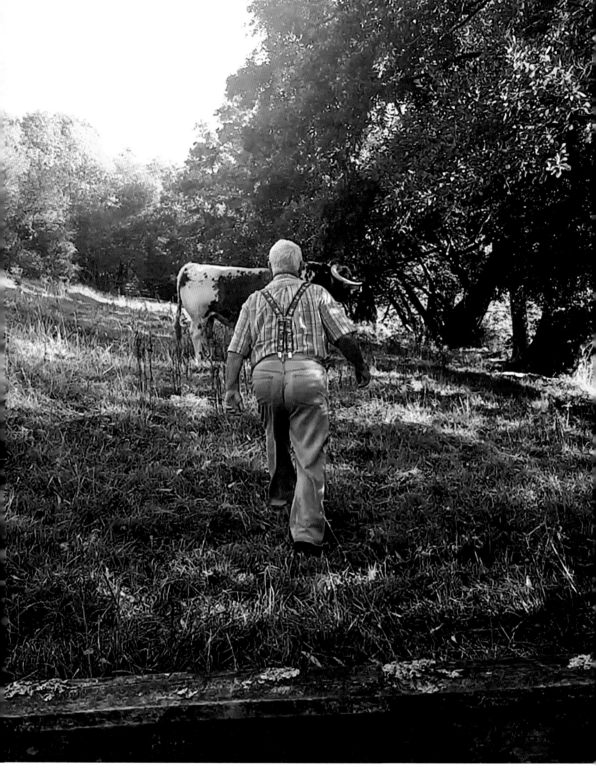

*A WALK WITH MALCOLM THROUGH THE WOODLANDS OF CHARITY FARM*

# A CONVERSATION WITH MALCOLM

'In the 50s and before, people had red and white Shorthorns, those or Ayrshires. And then the British Friesians came in. Then we began to cross them, and then you got a Blue cow. When I was a little boy, we had 15 or 16 Blue cows, and the first cross always gave a lot of milk. And then from the Friesian came the Holstein.'

'What was the reason they changed?'

'They bred out because the Holsteins gave more milk but they didn't last as long. A Holstein cow might last five years, if you were lucky, a Friesian cow might last ten years.'

'What about Shorthorn?'

'Well, a Shorthorn would last forever, but then they weren't being milked so intensively.'

'When I was little, we used to have about 23 cows, and then we had to progress, we had 30, then 35, then 40. And then when I was here, I had 60. When it got to 60, I'd had enough, milk prices were dropping and you were ruled by the milk quota. You needed to get more animals to produce milk to pay the bills and keep the farm going.'

To stay profitable he would have had to double the size of the herd, something he wasn't prepared to do and eventually they couldn't continue.

In the early 1990s, the milk board disbanded. 'Everything went to pot. You couldn't farm how you wanted to, and the squeeze came with everything.'

Over the course of 18 months, Malcolm made the difficult decision to sell the dairy herd. Having recently bought the farm, he was fortunate that in selling the cattle he didn't lose tenancy. But research suggests that economic pressures and retail consolidation have contributed to the continued decline of small-scale family farms in the UK.

In his lifetime, Malcolm has witnessed biodiversity loss on his farm and in the surrounding landscape. The absence of nature signposted the ecological impact of such a dramatic change in agricultural land use around the country.

'I've had the opportunity to see a corncrake', Malcolm says this nostalgically, as if I know what one is.

'I wouldn't have seen one if it wasn't for my uncle telling me to keep an eye out. He said: "Keep your eye out for him, he'll fly out like a water hen, a moor hen, they don't fly very high. He'll be the same size as a water hen but he'll be a different colour." And, sure enough, I was mowing the field and I perhaps had an acre left and he flew out. I tell people this, like I'm telling you, there is no one else my age round here, seen a corncrake in Halghton. Never seen one since.'

I delight in hearing stories of his time as a farmer. Experiencing a thunderstorm in his early twenties when about 500 frogs filled the roads for a two-mile stretch, slowing his journey from the farm and to the pub. Catching a salmon in the river just down the road. Lying by the brook surrounded by a carpet of oxlips, violets and orchids, pining for a young love, 'and the bloody skylarks would be singing, I'll never forget it'. Frenzies of insects, and little owls, 'they were everywhere'.

Habitat loss has been a major driver of decline in biodiversity in Britain, with such a high proportion of land cultivated for intensive agricultural use. Loss of hedgerows, wetlands, woodlands and change in management of grasslands, has contributed to a serious decline in hundreds of 'farmland' species. Birds that rely on farms for habitat and food sources have waned the most, with almost two thirds of species decreasing in numbers, including the corncrake, skylark and cirl bunting. These up just some of the 38 million birds that the chief executive of the RSPB describes as being 'lost from our skies' in the last 50 years.

After the sale of his dairy herd, Malcolm began to introduce cattle and sheep. The clay soils of Halghton and its species-rich pastures continued to produce a nutritious supply of food for grazing animals, as well providing habitat for species that have co-evolved alongside them. He brought in Limousins and then Longhorns. Both ancient hardy breeds supported the farm ecosystem and the conservation work Malcolm continued to undertake. As well as preserving watercourses and ancient woodlands, younger generations and trainee vets have been invited to engage with how food is produced at Charity Farm.

Malcolm's approach to farming, as he describes it, is traditional. A low-input, low-output system. Treading lightly and working with nature. Using methods that have gone much unchanged since his grandfather's time here and passed down by those before him. Principles that he hopes will help allow his grandchildren to experience the countryside as he has.

# BUYING A BULLOCK

Listening to the Limousin and Longhorn bulls stamp and puff at one another on a walk through the woodland, I wondered how fashion, and my practice, could connect to farms like this. The principles and inherited wisdom that Malcolm brings to farming provide multiple benefits that extend beyond producing nutritious food. As explained by environmental lawyer and rancher, Nicolette Hahn Niman, 'done with care, cattle husbandry enriches our human experience and enhances our natural world'.

The dominant narrative I had received through the media conflated the impacts of industrial agriculture by condemning farming as a whole. It felt clear to me that Charity Farm played a vital role in shaping the local rural landscape and culture. Both in my personal life through my food choices and in my professional capacity as a designer, I wanted to support this way of farming.

Still, I did not know what this meant for leather. My peers were interviewing for their first jobs, moving to exciting European cities and putting into practice what we'd spent years preparing for. My mum had noticed something change in the way I viewed my future as a designer in the final year of my degree. Forming new ties with the community my late father had been a part of was something she could see I didn't want to just drop, but I didn't have the funds to continue. A small sum of money had been left for me by my grandpa, which had been set aside for the future. We decided that putting it towards a self-directed education was a justifiable good use. Grandpa had been a farmer as well as a farm vet and had influenced my dad's interest in the profession. We hoped he'd approve.

'I'd like to purchase one of the bullocks you take to the abattoir next, please. Would you be open to that?'

It was a daunting request. We had, really, only just met. I was asking Malcolm to entrust me with a whole carcass of an animal that he had spent almost 30 months putting care and resources into rearing, with the intention that its meat would be sold and eaten by the local community. I promised that I would do the same with the majority of this bullock. Food was the link between farming and fashion, and I hoped Malcolm's produce would help facilitate that conversation as I attempted to create a collection.

43

Natural materials are the things that endure from farming systems once the plate is empty, but it is precisely the evidence of those histories that don't make

BULLOCK 374 ON 9 OCTOBER 2018

it to the materials I was working with. Malcolm's bullocks would be going to the abattoir whether I was there or not, the meat would be butchered and sold, and the hides would be removed and taken into a new industry.

Fashion must connect to biodiversity. Globally nature is declining faster than ever. Farms are a link between biodiversity, conservation and our health and well-being. Our connectedness to nature is something that is understood by many farmers. By asking these questions, I hoped to learn how fashion could be too.

Back at the table of Charity Farm, Malcolm showed me the documentation of the three bullocks he would be taking to the abattoir in three months' time. Since the late 90s, all cattle born or imported into Britain must have their own government-issued passport. Essential for traceability purposes, the passport must stay with an animal through all its movements, whether at cattle markets, changing owners or after slaughter, when the information remains linked to the carcass. The passport includes information such as the animal's date of birth, official ear tag number, breed and sex. Further detail of the dam (the mother of the animal) is also shown via their ear tag number.

We printed off a form provided by the Welsh government that, if approved, would give us permission to take away the hide and horns of one of the bullocks. It was daunting to be requesting to take responsibility for them. The responsibility brought with it the terrifying prospect of failing to give respect to the life taken for food or the people who made it possible. I realised these were fears that I didn't feel for the things in my fridge nor for the materials I'd used in the past.

'9am on the 9th then it is, Alice.'

Getting back into my car that day and pulling away, I remember feeling a swell of pride to have my name among the papers of Charity Farm.

Bullock 374. They were the last three digits of one of the bullock's ear tags.

# CHAPTER 2
# HIDE

The supply chain for leather starts, in a tangible way, at an abattoir. Here, the hide of an animal becomes what is considered a 'raw material'. The animal's hide is removed as a carcass is prepared to be hung and butchered. At the end of each 'kill day', depending on an abattoir's scale, it will have produced either a handful or hundreds of hides, which can be collected and turned into leather.

From weathering the elements, enduring bug bites and satisfying itches, the hide of Bullock 374 will show evidence of its life at Charity Farm. Hides have a value that is embedded in their very existence and quantified by their usefulness. Once removed, what the hide looks like, its size, surface character and thickness will go towards determining its end use as a material. Once removed, it is attributed a new worth, defined by a global raw material market.

If I didn't request the hide of Bullock 374, there were three possibilities: hides from Malcolm's cattle could either be collected for the domestic production of leather, exported to another country, or simply discarded. It was for these reasons that I found myself travelling to Charity Farm on 9 October with a camera and dictaphone. I was on my way to learn about the businesses that Malcolm relied upon to produce food, and see where the leather supply chain began for the animals of Charity Farm.

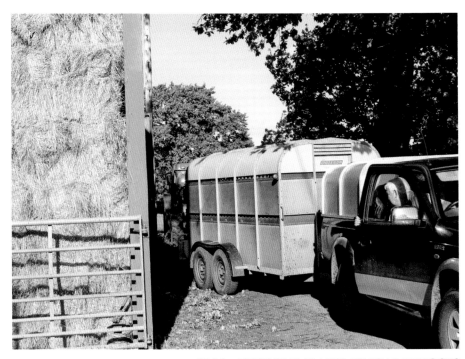

*10.33 – REVERSING TRAILER TO LOAD BULLOCKS*

# A SHORT TRIP

The farm was bright and still when I arrived that morning to accompany Malcom and the steers, including Bullock 374, to the abattoir. Malcolm has attached a trailer to the back of his truck and reversed it to face the door of the barn where the three bullocks have stayed overnight. A neighbouring farmer kindly helps with loading. Both men are familiar with the unpredictability of the situation. There is no underestimating the power these animals have. There is tension in the shared desire to get them in on the first attempt.

Having been born at the farm, these bullocks have never, or rarely, travelled in a trailer. Malcolm doesn't want to spook them. Each man has a different role in the loading; I stay back and quiet. To our collective relief they take the ramp and Malcolm, who stood blocking the gap between the trailer and the barn door, can swiftly close the trailer. We check and double-check that we have the correct paperwork before setting off. I clutch the pile of documents on my lap as we leave for the abattoir; Bullock 374's passport is on top.

The roads are quiet. We start our journey in silence. I don't want to disturb Malcolm as he concentrates on driving the truck and heavy trailer. Loading

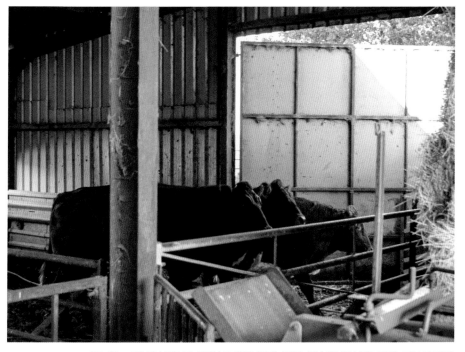

49

*10.40 – PREPARING BULLOCKS FOR THE JOURNEY TO THE ABATTOIR*

was just the first hurdle he hoped would be tackled smoothly and calmly. The second is the journey to the slaughterhouse. We have just less than ten miles to travel, which takes around 25 minutes at a leisurely pace, arriving on time for our allocated slot.

One of the first things I was told when I began to meet livestock farmers is that 'the last day is as important as all the others'. This care for their animals' welfare is one I have heard repeatedly from fields to conference halls and the distance of the journey to slaughter is one determining factor.

The scale of an abattoir will vary depending on the services offered and the market they aim to serve – from small town or village plants that slaughter just a few animals every week to those that cater to the supermarkets and exporters processing thousands of animals daily. Their function determines their size and location.

For a farmer, deciding which abattoir to use depends on whether they're selling into a wholesale market (where they will be paid based on the dead weight of a carcass that will be butchered and sold through retailers), or whether they sell their own products directly to customers (through a farm shop or online).

If Malcolm wanted to sell meat from his farm himself, he would need an abattoir offering a service called private kill. This is for farmers who wish to receive back the meat of their own animal, either as a carcass or butchered. The service, though not exclusively, is most commonly offered by businesses of a smaller scale – those that can or are willing to deal with farmers bringing only a few animals at a time, and that have the internal infrastructure to ensure that a farmer gets back the meat from their animals. This service is not only popular with smaller-scale farmers, but it is integral to any farm business that sells meat direct to the consumer, with a unique farm story attached and added value for its provenance embedded in the price of the produce.

Throughout the UK, abattoirs providing this service are unevenly distributed due to decades of small-scale abattoir closures, leaving large areas of the country entirely unserved. These closures bring increased pressure on farmers forced to travel further distances, which creates concern for their animals' welfare and an additional expense for their business. As a result, less than 7 per cent of the cattle slaughtered in England are taken to small-scale abattoirs. It is not an exaggeration, therefore, to say we were heading to a valued linchpin of the local farming community.

# THE ABATTOIR

Just after 11 o'clock, we turn down a single-track side lane of terraced houses in the heart of a village. Halfway down the stretch, we turn into the abattoir yard. I think about the neighbours: from their bedroom windows they can see into the small yard, see the parked white vans, the giant refrigerated facility and the steel doors of the slaughterhouse.

The Thomas's have been in business for three generations. This site was established as an abattoir in 1973. The town was likely less developed then and I imagine that this plot is worth considerably more now. A couple of streets away, they operate a butchers' shop for which they procure meat from farms in a 30-mile radius.

### 11.22

Before the cattle are unloaded, the paperwork I am clutching must be looked over by the abattoir manager and vet. With the cattle passports is the form certifying that Malcolm has permission to retrieve what is legally termed 'animal by-products' (ABPs). A note has been made: we specifically desire the return of the hide and horns belonging to Bullock 374. Crucially, the Animal and Plant Health Agency approved our application and we have met the requirements of the Animal By-Products Regulation. By showing these stamped forms, our hope is that there will be no trouble retrieving the hide and horns from the abattoir.

Eyebrows are raised at the sight of our unusual request. 'You can have it, if you want, but tanneries don't want them'. We'd called ahead with this request and we'd been warned the same then. I was keenly aware that the bullocks were still in the back of the truck and this request was holding things up for everyone. But instructions needed to be passed on to the men inside the abattoir and without a plan to set it aside, the hide and horns would be much harder to retrieve. I reiterated that I would make use of the hide, still unsure of the reasons why a tannery wouldn't want them.

We needed to make the request now because once the cattle were unloaded, the hide would not belong to Malcolm. The hide, along with the horns, feet, fat and offal comprise the 'fifth-quarter' of an animal. When the carcass is butchered, it is first divided into quarters: two forequarters and two hindquarters, with a leg remaining attached to each quarter. A farmer is paid for the 'dead weight' of a carcass, which includes meat and bones, but not the fifth quarter. Products that make up the fifth quarter are owned by an abattoir. These can be sold on

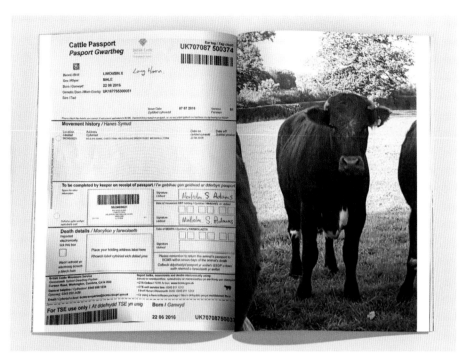

*BULLOCK 374'S CATTLE PASSPORT*

to different vendors. Historically, these sales have been a reliable source of additional revenue and impact the price an abattoir needs to charge farmers for using their services.

Typically an aggregator will purchase hides from an abattoir. The price they pay for them is affected by the market they can sell them into. And while over the last ten years cattle have continued to be reared for meat, the demand for leather has steadily declined. This has resulted in a dearth of raw hides. Consequently, a fluctuating market has meant that, for some abattoirs, the value they garner for the raw materials that they produce is inconsistent and unreliable.

Thomas's is a small-scale abattoir, producing a relatively small number of hides per week. Its rural location and low throughput, coupled with the reasons above (and others that I will soon learn of) culminate in the hides of Malcolm's cattle being discarded at the end of that day. I learn that asking for the hide back was actually not a problem for them – once removed, they are usually put into Category 3 'waste' and will incur the cost of disposal.

**11.26**

With the paperwork sorted, it is time to unload. Men in white short-sleeved T-shirts and olive-green waterproof aprons pull the heavy steel doors open. Through the air holes in the trailer I can see the hairy backs of the steers. Travelling together has kept them calm, but they begin to jostle at the sound of the trailer ramp being unlocked. I stand well out of the way as the trailer ramp is lowered. One at a time, the gates are unfolded and positioned to direct the steers into the lairage that, from what I can see, looks like a stable.

I already knew they wouldn't be there for long because before we left the office, we'd been told to return for the hide around two o'clock. Between now and then they would move from the lairage to the kill pen. There they would be stunned by a captive-bolt pistol, causing them to lose consciousness. Once senseless,

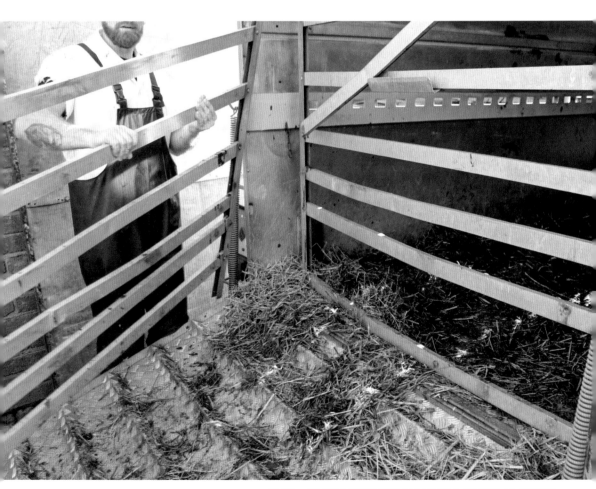

*11.26 – UNLOADING THE BULLOCKS AT THE ABATTOIR*

they are unable to feel the next step (exsanguination) which is the cause of death. When carried out correctly, this is considered the most humane death for cattle because it is quick and painless and does not cause the animal stress. Assuring animals raised for food in Britain receive a humane slaughter is a tenet of the Animal Welfare Act.

We have time before we need to return to the abattoir, so Malcolm asks if I'd like to see where the meat from these animals will eventually be sold. Ten minutes later, I see the most recent customers swish out of the metal chain curtains of M. E. Evans Butchers. Their departure makes room for us in the small square shop. Display fridges with curved glass fronts display their offerings. Metal dishes hold a range of produce from raw to cooked: local lamb leg steaks, Welsh shin of beef, homemade pork pies, and soon, local Longhorn beef (from

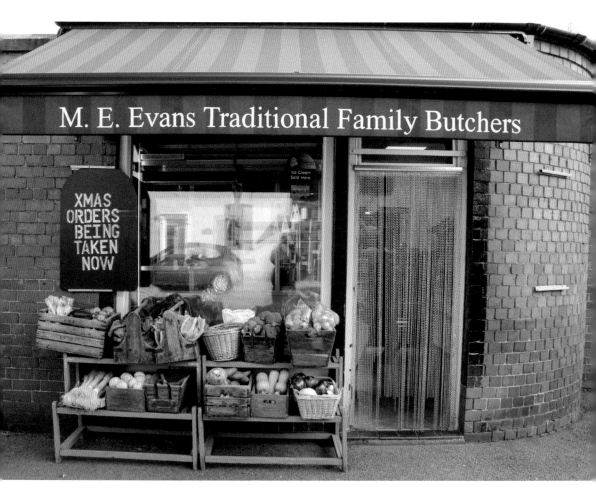

12.04 – LOCAL BUTCHER, WHICH WILL SELL SOME OF MALCOLM'S MEAT

Malcolm's animals), which I am told by the man behind the counter, will all be gone in a matter of days.

It was suddenly clear to me that for Malcolm to sell his meat locally, and for Evans Butchers to supply customers with a story of the locally raised meat, Thomas's abattoir played a crucial role. Each business is dependent on the other, and as a result food miles are kept short and traceability is assured. A fair price for meat, one that reflects the true cost of its production, can more easily be negotiated outside the constraints of commercial contracts.

**14.30**
Back at the farm we wait for the phone to ring, signalling it is time to go and collect the hide and horns of Bullock 374.

Tersely pushed into a heavy-duty plastic bag, it takes two men to drag the hide from the building over to us. As they reach the boot of the truck, I see they've provided extra assurance that this came from Bullock 374. Instead of removing the identification tag along with the ears, which is often standard practice, the ears remain intact and attached to the hide. I am assured that extra care was taken in its removal, information I will soon see to be true.

After the hide is lifted into the truck, we are handed a bag that contains the horns of Bullock 374. All loaded, we head to the farm.

**15.23**
Warmth emanates from the bag as it is lifted from the truck and into a waiting wheelbarrow. Roughly, the hide weighs 36kg. It takes both my uncle, who has offered to help, and Malcolm to lift it.

The hide needs to cool before we can begin to preserve it. To speed this up, we lay it out flat. I unfold it and drag what I think is the skin that covered the belly and back leg to one side of a large raised bed of pallets. It is warm and wet. I am not sure if it is its size or the experience that renders us all silent.

The hide represents almost all of what we know to be familiar of the living animal, markings that have made Bullock 374 identifiable in the field, such as the pooling of white hair from belly to breast and its tiger-stripe brindled coat. We pull the hide open so the hair side lies against the wood of the pallets and the flesh side upwards, open to the air.

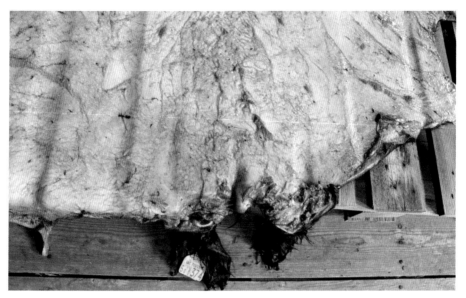

*15.23*

The instructions I'd been given from the tanners ring through my ears loud and clear. I'd called around for advice on preparation. This was the one point of the day that I was responsible for getting right. Hides can easily be ruined in the preservation stage, either from accidents or carelessness. I focus as Malcolm stands nearby. This sight was a first for both of us.

It had been important that we'd collected the hide soon after its removal from the carcass. During life, processes regulate the skin to ensure its function and resistance to external chemical, physical and biological agents. When the animal dies, biological activity ceases and the skin, along with all other tissues, are no longer protected and become susceptible to rapid decay.

To stop this from happening, I need to cover the hide with salt, roughly one third of its total weight. But, before I begin, I have to check that all the salt will penetrate the skin.

**15.54**
My first instruction, look for fat and meat that may still be attached to the hide. If too thick, the salt won't be able to get through. I scan the hide and see the faint blade lines from the flaying knife. Sweeps of scores travel horizontally across the width of the hide (perpendicular to the spine). Care has been taken not to nick or puncture the hide. It will have taken longer than usual to avoid causing damage during the hide's removal.

57

Flaying is a skill. This method of removing a hide with a knife is historic and the dexterity needed to do it successfully is achieved through observation and practice. Teaching would have been passed down from slaughter man to slaughter man. In modern practice, a machine is used to pull the hide from the carcass. But prior to these machine pullers, flaying was the only way to remove the hide of an animal. And, when hides were highly valued and sought after, damage could result in a fine. Today, the worth of a hide is comparatively very little and hides are abundant, so traders choose the raw materials with qualities best suited to a competitive market.

Flaying is primarily now used at smaller-scale facilities with lower throughputs, as a hide puller is an expensive investment which takes up space. It is often a butcher's preference to have the hide removed this way as additional care can be taken to keep the fat of the animal attached to the carcass, fat that may be stripped by the speed of a mechanical hide puller, and which is crucial to taste.

Running my finger over the dark pink lines I check the cuts haven't gone deep. The aim of flaying is to split the carcass from the skin but not slice into it. A cut just a couple of millimetres deep can alter a hide's potential uses. For this reason, hides removed by knife (flayed) are categorised as such when sold.

With small, sharp knives, my uncle and I carefully remove the few pieces of meat and fat that we find. As we move around the hide, I am reminded to make sure there are no folds, to spread out the hide, but the skin that had wrapped

*15.55*

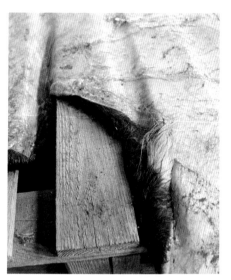
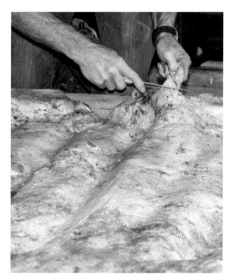

15.52                    15.56

around the front legs and rolled over the belly won't lie flat. It recoils on itself like a crease resistant to ironing.

At this moment, the hide represents the connection between food and land. Rolling the edges of the hide back takes me from touching mud from the fields which clings to the hair, to a knife mark of where we have just removed the remaining meat. In between is the fibre that will be transformed into leather, creating a material connection to Charity Farm.

In this state, the hide presents a liminal place between farm and fibre.

## 16.12
The salt we scatter acts as a preservative, reducing water content and inhibiting bacterial activity that could damage the hide. We scatter salt all over in every nook and ridge, leaving nothing bare. I am glad Malcolm is there to see. Knowing that the two hides from the other bullocks we'd taken that morning were slumped in a bin for disposal, it felt almost ritualistic to ensure this hide wouldn't be wasted.

In other ways it felt defiant. The cost of disposing of the hides would be paid by the abattoir, an expense that would need to be accounted for elsewhere in their business.

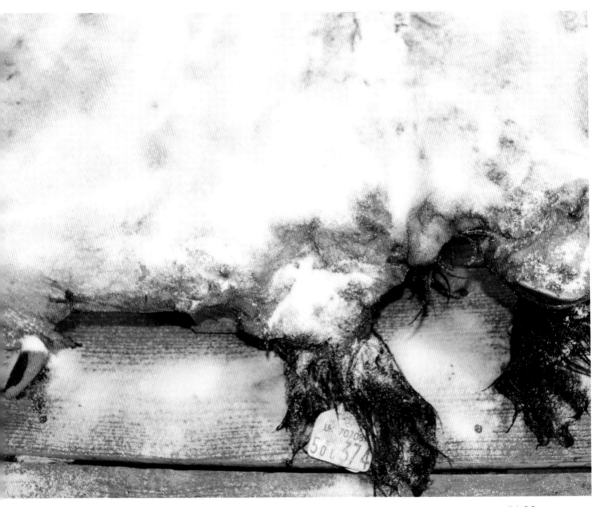

16.20

## 16.20

The raised slats of the pallets on which the hide is laid will allow the liquid to drain over the following days. Depending on the size of the hide, there can be up to 20 litres of run-off. As I only have the one hide, I will leave it laid out for five days. When the majority of liquid has gone, I will reapply salt for safe measure. Two regulatory weeks of preservation are required before transportation.

We stand back and look at the dusting of white on the hide of Bullock 374. My over-precaution has created a blanket of salt and nothing can be seen now except for a bit of brown hair holding the ear tag.

I take another look inside the bag that contains the horns. They too would have been categorised as waste. As they have only been growing for 27 months, they do not resemble the sweeping horns of the heifers back at Charity Farm.

They also look nothing like the beautiful objects I've seen crafted into water goblets or jewellery. These looked stunted. Any usable horn lies in between an exterior of soft brown tissue and a hard pink sinus cork in the centre. A forum online had suggested I bury them in soil and let microbial activity eat away at the tissues that encased the horn. We take the bag and bury the horns in a patch of earth, marking it with a stick, unsure how long it will take for any change to happen.

In the weeks that followed, I thought about the carcass of Bullock 374 hanging in Thomas's refrigeration room. Neither the hide nor the carcass resembled the neatly packaged goods on offer on supermarket shelves. Both would need to go through a transformation before they resembled anything like the food or fashion I was familiar with.

*HORNS OF BULLOCK 374*

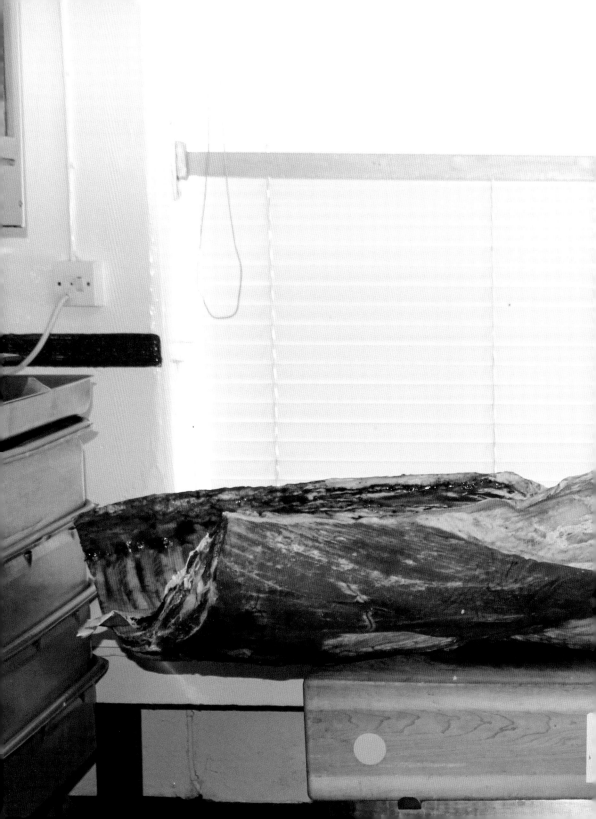

# CHAPTER 3
# A DAY
# WITH JOHN

Nearly three weeks after driving Malcolm's bullocks to the abattoir, I arrive at John Roberts' butcher's shop in the tranquil village of Hanmer. Cushioned on all sides by farmland, there are few ways through the black-and-white, thatched and red-brick houses, pub, shop, church and school that cluster on the edge of a glimmering mere – or glacial lake, as it is more splendidly called – so not even I can miss Mr Roberts' shop.

John walks out in his blue-and-white-striped uniform, colour co-ordinated to his backdrop, wearing a thickly brimmed white hat. Independent butchers like these are often important routes to market for small-scale farmers such as Malcolm. Butchers can share valuable information about farm practices, right down to the breed of animal. This added value of detailed traceability can add to the premium a farmer can receive for their carcass. Today, John will be ensuring that I will be able to do the same with Bullock 374.

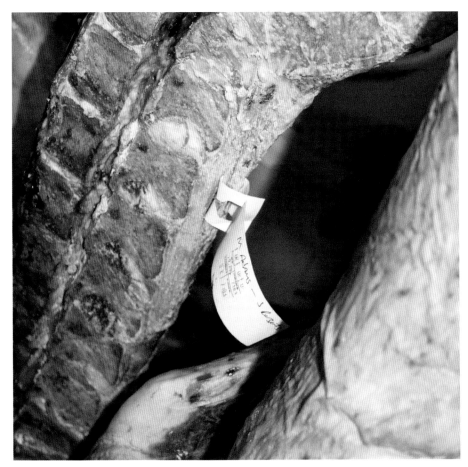

*BULLOCK 374'S CARCASS IN JOHN'S FRIDGE*

Malcolm's produce has always been sold locally, through different vendors but always reaching his community. Whole, half or prime cuts of a carcass would go to the village pub, a blackboard sign signalling Malcolm's hogget or beef often hanging above the fireplace in the Hanmer Arms. Or they would go to the butcher, labelled as local Welsh Longhorn.

At other times, Malcolm would sell meat to customers directly from the farm gate in the form of meat boxes. One of the services of Thomas's abattoir was cutting whole carcasses down and separating them into boxes for retail, each box containing roasting joints, steaks, mince, braising beef and fillet: 'a bit of everything from the animal', as Malcolm explained to me. The sales of his produce this way forged a connection between Charity Farm, its animals and those who ate them. Customers were able to learn where and how the animals were raised, on what pasture and who the people involved were. This knowledge can be important to someone when choosing their meat, and it is information that farms such as Malcolm's are proud to share.

I had approached this project wanting to learn about the places and people that were connected to the fibres I was working with. At university, when thinking about leather, I had begun to ask: Who did this animal feed? How many people? Where? When? What were the practices that reared it and what were those impacts? If I had answers to these questions, the materials I was working with would have had more context and meaning beyond just their aesthetic appearance.

I quickly realised that I had no idea what one animal could yield in the form of both food and fibre. Walking through supermarkets, perfectly portioned cuts were replicated and the same labels repeated. I'd only ever been on the receiving end of fragmented information.

The decision to purchase the whole carcass of Bullock 374 wasn't taken lightly. But I felt strongly that while exploring fashion's relationship to farming systems, I needed to retain the food aspect too. I wanted to share information about the meat produced from Charity Farm and, in turn, sustain the link between farming systems, food and fashion. It would be, I hoped, an education for myself and an opportunity for others to experience that connection.

# THE BUTCHERY

We have a long day ahead and I am not entirely sure what it will entail. This is my first time seeing a whole carcass butchered and many of the decisions on how this will be done are for me to make. The task feels enormous and, despite John's decades of experience, he admits he wouldn't usually take on a whole beast – as he calls it – in one day.

John was trained by his father, as was his father before him. His craft has been honed inside the cold white walls and red-tiled floor of the shop, which has been functioning as a butcher's since 1926. Malcolm's and John's families have been friends for generations, since this business once operated as a small abattoir. Malcolm's grandfather would walk his cattle the three miles from Charity Farm to be sold to John's uncle, where they would be slaughtered, butchered and sold. Today, the function of the shop remains the same, to provide a bridge between farm and community.

That morning, John had made two trips to Thomas's abattoir to collect the now-quartered carcass of Bullock 374. All four quarters of Bullock 374 have been hanging for 20 days, with labels looped through thick yellow strips of fat containing the custody instructions, M Adams – J Roberts, signalling the next stage of the journey towards a plate.

I'd studied diagrams in preparation for this day. Black-and-white graphics, pencil sketches, cattle that had been segmented like building blocks or with labels signposting the generalised make-up of a bovine carcass.

There were names and often drawings extrapolating from the carcass to show the shape of each cut, but there were never any weights or references to size. In each diagram, I looked at the dotted lines marked within the carcass, each would run through slightly different points and were often given different names, and in one case the front legs had just been named 'gravy'. Seeing the carcass in front of me was an entirely different picture. There were no neat lines or guides to cut. John's trained eye intuitively knew them, but I'd need help.

# GETTING STARTED

I had discussed a plan with Malcolm.
As the carcass had been split in half, I
decided I would cut each side differently.
Half of the carcass would be divided
into smaller sizes: steaks, joints, bags of
mince and stewing steak that could be
eaten with family and friends – similar to
how it would be found in retail.

The other two quarters would be left in
larger joints, more closely representing
their true size. I planned to sell these
larger cuts to restaurants and organise
dinners where the menu would be based
around the extent of the meat available.
The hope was that I could later unite
the food and fibre of Bullock 374 at these
occasions. I shared this plan with John.

**09.31**
Bullock 374's expanse exceeded John's
shop. The left two quarters hung in his
vault-like fridge, while the right quarters
lay in the back of his van, ready to be
lifted onto his butcher's block. A metal
S hooked through the left hindquarter,
while the left forequarter hung from
twine. They met in the air nearly at the
point at which they'd been cleaved apart.

The room we were standing in was
empty and immaculate. I was surprised
at how little there was to help us
with what came next: some knives, a
sharpener, spool of string, an assortment
of hooks and a mincing machine. At the
back, planted upon a steel frame, was the
butcher's block.

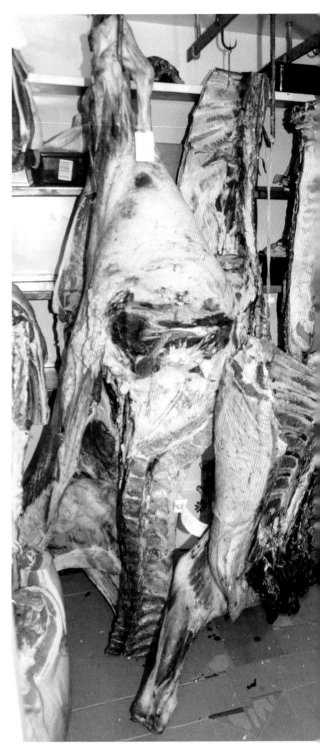

*LEFT HINDQUARTER AND LEFT FOREQUARTER*

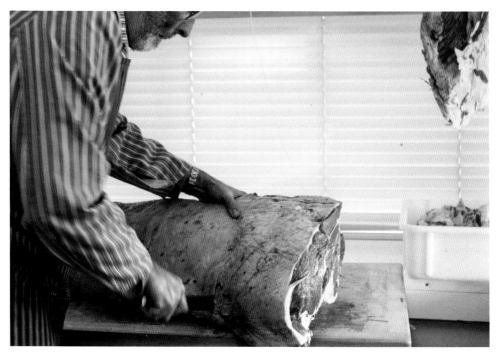

*10.10 – CUTTING OFF THE RUMP*

# RIGHT HINDQUARTER

**09.32**

With a thud John lands the right hindquarter of Bullock 374 onto the block. I now understand why he's driven his van so close to the entrance of the shop – it can't be carried by one person further than a few paces. Just this quarter weighs approximately 75kg. It dwarfs the block. The shin, outstretched at almost a 45° angle, hangs over one end, with the ribs jutting from the other. 'So, how do you want to go about this?'

**09.33**

We begin work. The flank, a long strip of the abdomen, is the first to be sliced and then sawn off. John uses his long butcher's knife and follows from the hip through the abdominal muscles, tapering upwards towards the spine until he hits thicker meat and the lower ribs.

**09.34**

Here he straightens up and uses the saw to cut through the bottom four ribs. The flank is a long triangular shape. Taking one of the spiked metal hooks, John pushes it through a dense piece of fat and hangs it on the steel frame above us. From there, we are off.

**09.36**

John separates the hindquarter into two. With this division, things begin to feel more navigable. Now, when slanted at different angles, the quarter

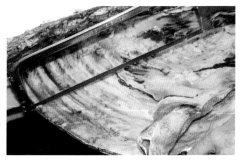

09.34

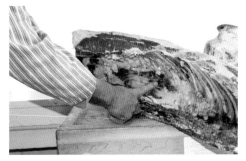

09.37

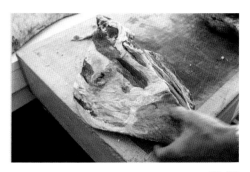

09.38

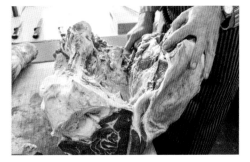

09.45

can be contained on the well-worn wooden block.

**09.37**
John pivots the loin to show me the fillet. Its darker, purple-y mass is encased in swirls of fat and visible from the inside of the carcass.

**09.38**
We begin cutting large joints from the rear of the quarter. When John split the quarter in two, he kept the shin and femur bone connected. From just above that connecting joint, John carves out a hunk of meat, the thick flank.

**09.44**
The shin is cut away from the femur and hooked onto the steel bar above us.

**09.45**
Next to be cut away from around the leg bone is the topside. Its size and weight mean it peels away easily from the bone.

**09.48**
It needs two hands to manoeuvre onto the block for further trimming. The size amazes me. Topside has been a family favourite in our house, with many happy Sundays centred around the roasting of the joint. This piece was ten times larger than I'd ever seen. I imagine it being shared with lots of people and decide to keep it whole.

**09.56**
A stream of cuts with names that I'd never heard of before are carved out in impressively quick succession:

69

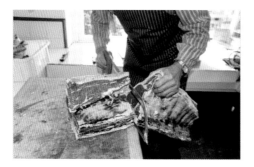

*10.21*

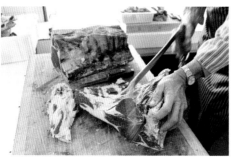

*10.23*

*10.44*

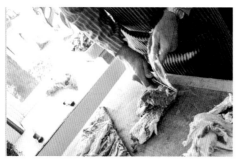

*10.47*

the salmon cut, followed by the silverside and the skirt.

**10.02**
With all the large joints cut from around the femur, any remaining meat is stripped from the bone and set aside for mincing later.

**10.05**
John moves to place the femur in the box that we will be using to put bones in. He stops and brings it back to the block. 'You would have got a clippin' for leavin' that', he says, removing a slither of meat from the nearly bare bone.

With all the meat stripped and joints cut from the leg and shin, John can move on to the second part of the quarter. First, he cuts and saws off the rump just above the hipbone and prises out part of the fillet. 'That's rump steak or a rump joint.'

**10.21**
John rests the remainder of the hindquarter on its spine and saws it in two. Only the sirloin remains from this quarter.

**10.23**
'I'll just chine it for you'. I'm not sure what that term means and John explains it's the loosening of the bone, which makes carving easier. 'That's a piece of boned sirloin', he points back to the cuts on the block, 'call it sirloin steaks if you like, or strip loin is as good as anything... Tomahawk steaks... that's

10.56

11.03

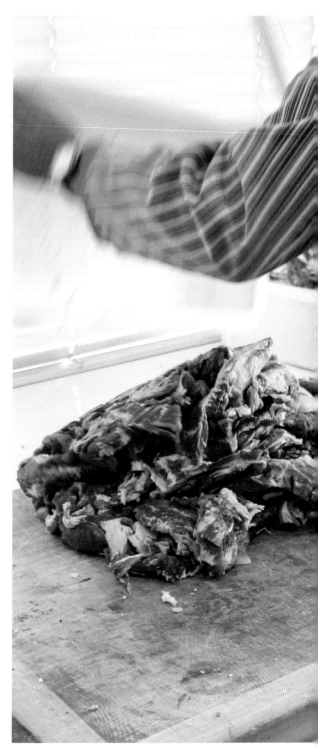

a popular thing now isn't it, it's
all modern now... It's just a way
of selling things'.

**10.35**
Malcolm arrives just as the flank is
unhooked from the bar above us. John
begins to carve out the embedded bones.
All of the leaner meat will be minced,
along with the chunks that have already
accumulated, towering in the tray sitting
beside us.

'Morning all!' says Malcolm. 'There was
a nice covering of fat on here, John, I
thought, just about right.' Earlier, I'd
been taken aback at seeing the carcass in
its unsterilised wholeness and surprised
to see the yellowy colour of the fat. Later,

10.54

a farmer will remark, 'Something has eaten plenty of grass.' They deduce this from seeing the bloom of colour which is caused by a naturally occurring pigment in grass.

**10.54**

Our last job for this quarter is to mince these trimmings. John clears the block for the contents of the tub to be poured onto and chopped up. There is more than 10kg of meat to mince from this quarter.

**11.04**

With the hindquarter completed, John calls for a tea break. 'Are we doing a forequarter next or another hindquarter?' Forequarter please, I say, eager to grasp a picture of Bullock 374 so that what I learn may direct the afternoon's decisions when we come to the second half.

**11.21**

The right forequarter is also in the back of the van. It's much easier to lift being wider, shorter and lighter than the hindquarter.

# RIGHT FOREQUARTER

**11.22**

This time, unlike with the hindquarter, the shin is removed first. To start, John uses the knife to cut an outline of where the foreshin hinges with the humerus.

**11.23**

He then has to lever the shin, before breaking it off and hanging it up.

**11.24**

The first cut made is to the neck area, which John calls the clod. Lots of meat – ideal for stewing – is diced.

**11.26**

Using the saw and following a straight line from under the neck down to the ribs, John cuts away the brisket and hooks it above the block.

**11.27**

The ribs are the next to be cut away whole. The bones that extend with only a thin covering of meat are sawn off, making a rectangle of white stripes.

**11.30**

John tightens the string in knots around the rib that push into the creamy yellow fat. 'That's the leg of mutton cut', John explains as he cuts a large joint from near the shoulder, 'But my dad used to call it the crop. It used to be cut down the middle and into four joints.'
I take the opportunity to admit to John

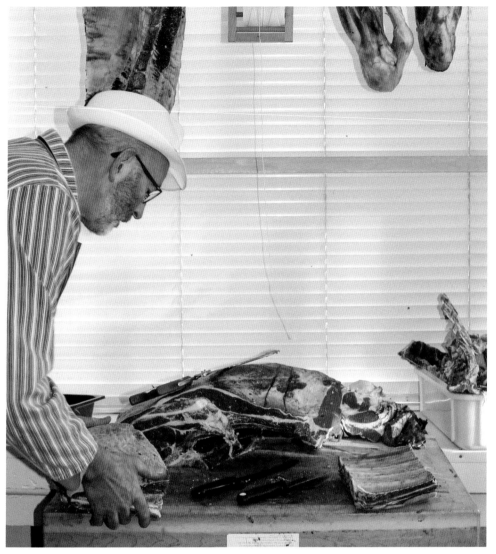

*11.27 – PREPARING THE RIGHT FOREQUARTER RIBS*

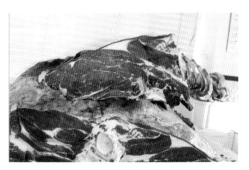

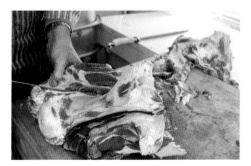

*11.24*

*12.10*

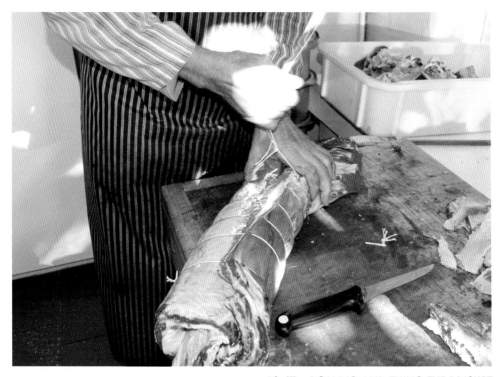

*12.47 – ROLLING AND TYING THE BRISKET*

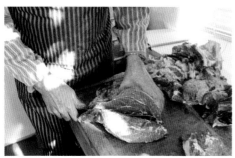

12.22

12.34

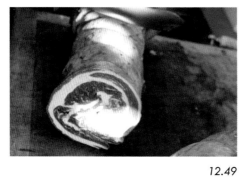

12.49

12.53

that I'd done some studying but was struggling now with names that I'd not heard of before. He stops and goes to pick up a book. 'Is this what ya mean? A picture like that?' He points at both pages in the open book, on one side the American and the other British cuts. I ask what the difference is and John tells me everyone's got a different way of cutting, that he'd likely have a different way than another butcher because he learned from his father, and times change. Looking at the diagrams I saw how the carcass was divided into the prime cuts, and additional detail indicated names of joints found within those sections – the sub primals. As the cuts got smaller, I noticed names I'd recognised and seen in retail stores, but I realised I didn't know some of these names John was calling out.

An advantage of independent butcher's shops is choice. While supermarkets must present a range of produce that is deemed most popular, John can draw on knowledge of traditional butchery. We keep the joint whole and I name it leg of mutton cut. Weeks later, it will cause lots of confusion and I will have to google the more widely used name: thick rib or the runner.

**11.51**
We are deliberating about the chuck. First the shoulder bones need to be removed. 'There's some nice steak there in slices. Let's get rid of this bit first [the top], this is just the trim for mincing'.

**11.55**
John removes the scapula, leaving a huge joint of chuck. We decide to keep it almost whole. Meat is trimmed off to neaten it up and added to the now close-to-toppling stack of cubed stewing steak.

**12.10**
All of the remaining meat is stripped from the humerus bone and I can now clearly see how the ball had been perfectly engineered to meet the scapula.

**12.22**
A slab of meat is trimmed and then cut into six thick braising steaks.

**12.34**
John lifts down the brisket he'd cut off earlier. First it needs to be de-boned, which involves removing the breastplate by using the saw and then taking out the ribs. This takes ten minutes or so and I'm not sure what John's plans are for it next, until he says, 'then we roll it up'.

**12.47**
The most impressive butcher's knots are used to secure the roll, ten in total. John then cuts it into three joints, fat swirls turning to marble inside the rolls. 'You want to slow cook, then this all melts.'

So far, we've been working for three and a quarter hours and are halfway through butchering the entire carcass. The midday sun filters through the slats of the shop dropping spotlights onto the meat.

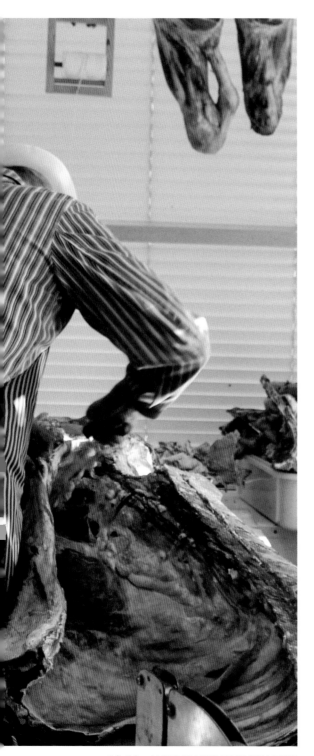

12.54 — WHOLE LEFT HINDQUARTER

# LEFT HINDQUARTER

**12.54**

John lifts up and unhooks the left hindquarter from the roof of the fridge and carries it to the block. He is able to manoeuvre the shin towards the far back window and turn the quarter on its side so that the hollowed cavity of Bullock 374 faces the ceiling.

With two quarters complete, I try to use the experience of the last few hours to inform how we cut some of the second half of Bullock 374 into smaller family-size joints, single cuts and steaks.

Above the block, the hooked shins provide a literal indication of the day's progress. John offers to cut them up for me. A popular choice is to have bone-in shin, but I decide against it. Unlike the other cuts that have been pulled from the carcass and neatly packaged with new names, the shins are powerful reminders of the scale of Bullock 374.

By now we've found a rhythm: slice, pull, tie, tighten, cut, bag and sharpen. The thick flank is divided into two and the large hunk of rump that I'd kept whole is this time cut into steaks.

**13.34**

John turns the remaining quarter on its side; from here we can see the whole fillet and its rich plum colour permeating through the yellowy fat. This time,

John removes it whole. Once it's out, he removes strips of coarse pearly fat and quips that it would make a great Beef Wellington. I hope that it does.

**13.53**
We decide to cut sirloin steaks. First, John saws the spine to separate the sections of sirloin and then carves out the meat that had been encased between the spine and ribs. The shape of the slab's cross-section is instantly recognisable as that of a steak.

**13.54**
He trims a couple of inches of fat from the slab, leaving a three-quarter covering over the rest. 'The flavour is in the fat', I hear Malcolm say again.

**13.55**
John slices widthways and cuts 12 slabs.

**14.51**
The tray containing the meat for mincing was already towering before John started de-boning and adding the flank. There will be more mince produced because of the way we've chosen to divide this hindquarter, which makes sense as we'd been cutting down joints to be smaller as we'd gone along, trimming and tidying them up.

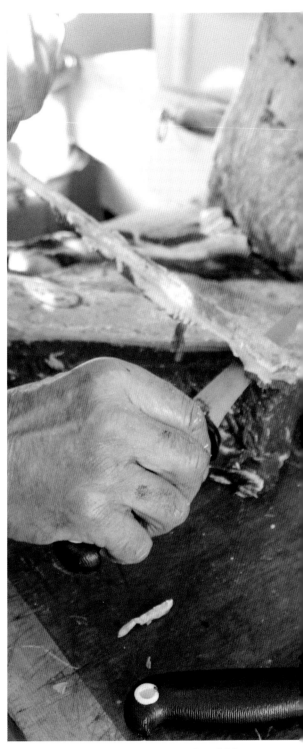

*13.54 – TRIMMING FAT FROM THE SIRLOIN*

# LEFT FOREQUARTER

The left forequarter is last to be carried out of the fridge.

**15.52**
The brisket is sawn off and hung by the four shins. The skirt is diced.

**16.01**
The scapula is removed from the shoulder and the leg of mutton cut carved out and divided into two this time.

**16.11**
John removes the clod (neck) and begins to 'tidy it up'. This involves removing the bigger pieces of meat and fat and dicing them into stewing steak chunks. As a whole piece, the neck is large enough to be cut into braising steaks.

**16.28**
What remains of the forequarter is the chuck. This time, it is cut into two joints. More stewing steak is trimmed from around the two joints and I begin to bag up the chunks.

**16.45**
Finally, John lifts down the brisket from the hook above him, leaving the four shins behind. De-bonding the brisket is one of the final preparations of the day.

**16.48**
John rolls the brisket as before, securing the swirl with string and then cutting into three joints.

I bag up the shins whole and label them. We're done.

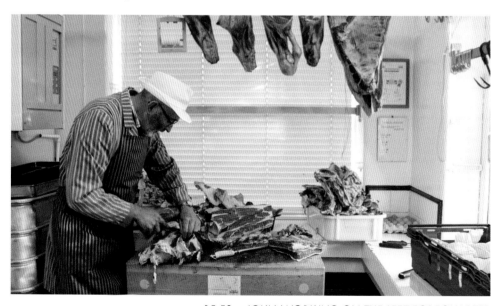

*15.52 – JOHN WORKING ON THE LEFT FOREQUARTER*

# CLEANING DOWN

**17.10**

The sun has set long ago. Outside the sky is a sapphire blue. Scrubbing the wooden block with a coarse brush is the last stage of the clean down. We've minced and bagged up fat and some bones for me to use. John has arranged for the rest to be taken to the knacker's yard where they will be used by other industries. The top surface of the block is taken off, removing the residue of today's work and any remnants of Bullock 374. By the time we finish, the place glistens in the dull evening light, ready to go again tomorrow.

I load up the car with the last remaining boxes of bagged-up meat. On each cut I've scrawled identifying details. Over the coming weeks I will transfer this into spreadsheets, along with information about Malcolm, John and Charity Farm. This will be circulated among friends, family, my old school and local pubs. With each sale there is an accompanying note, detailing where the meat has been cut from on the carcass and an invitation to share with me where, when and with whom the produce is eaten. I'm not sure if anyone will do it, but I'm excited to see.

I get home and pack my notepad away. Scribbles and diagrams fill the pages. I can't yet get my head around the quantity of meat from Bullock 374 now sitting inside the two chest freezers at my uncle's farm, or the journeys and logistics that need to be arranged in order to distribute it all.

# INVENTORY OF CUTS

**Right forequarter**

Foreshin

Neck
(diced)

Chuck
braising
steaks

Leg of mutton cut

Rolled
brisket

Top rib

Jacobs ladder

Flank
(diced)

Sirloin

Sirloin on
the bone

Flank
(diced)

Stewing
steak
bags

Fillet

Mince
bags

Rump

Thick
flank

Skirt

Topside

Silverside

Salmon cut

Hindshin

**Right hindquarter**

## RIGHT FOREQUARTER
**Foreshin** 4.1kg (V&A dinner)
**Jacobs ladder** 2.1kg (Community)
**Top rib** 5.28kg (Hanmer dinner)
**Leg of mutton cut** 4kg (Local community kitchen)
**Chuck** 6.5kg (Hanmer dinner)
**Rolled brisket** 2.2kg (Family)
**Rolled brisket** 1.8kg (Community)
**Rolled brisket** 2.3/2.8kg (Family)
**Braising steak** 0.96kg (Community)
**Braising steak** 1kg (Friend)
**Braising steak** 1.1kg (Me)
**Stewing steak bags** 1.5kg (Family)
**Stewing steak bags** 1.5kg (Family)
**Stewing steak bags** 1.5kg (Family)
**Stewing steak bags** 1.5kg (Family)

## RIGHT HINDQUARTER
**Hindshin** 5.9kg (Hanmer dinner)
**Thick flank** 4.85kg (V&A canapés)
**Topside** 9.1kg (V&A dinner)
**Silverside** 5.8kg (V&A Members' Eve)
**Salmon cut** 2.78kg (Friend)
**Rump** 4.85kg (V&A dinner)
**Fillet** 1.36kg (Friend)
**Sirloin** 5.2kg (Hanmer pub)
**Sirloin on the bone** 5.8kg (Hanmer pub)
**Skirt** 0.5kg (Friend)
**Mince** 2kg (Family)
**Mince** 1kg (Community)
**Mince** 1kg (Community)
**Mince** 1kg (Family)
**Mince** 1kg (Community)
**Mince** 1kg (Me)
**Mince** 2kg (Family)
**Mince** 1kg (Family)

## LEFT FOREQUARTER

**Foreshin** 4.7kg (V&A dinner)
**Jacobs ladder** 2.3kg (Friend)
**Top rib** 5.3kg (Hanmer pub)
**Leg of mutton cut** 2.6kg (Local community kitchen)
**Leg of mutton cut** 2.9kg (Local community kitchen)
**Chuck** 5.6kg (Hanmer dinner)
**Chuck** 4.3kg (Hanmer dinner)
**Rolled brisket** 2.1kg (Family)
**Rolled brisket** 2.3kg (Community)
**Rolled brisket** 2kg (Family)
**Braising steak** x 5 0.5kg (Family)
**Stewing steak bags** 2kg (Local community kitchen)
**Stewing steak bags** 2kg (Community)
**Stewing steak bags** 3kg (Family)
**Stewing steak bags** 1.5kg (Community)
**Stewing steak bags** 1.5kg (Friend)

## LEFT HINDQUARTER

**Hindshin** 5.8kg (Hanmer dinner)
**Thick flank** 2kg (V&A canapés)
**Thick flank** 3.1kg (Family)
**Topside** 3–4kg (V&A dinner)
**Silverside** 2.5kg (V&A Members' Eve)
**Silverside** 3kg (V&A Members' Eve)
**Rump steak** 0.6kg (Moreton Hall)
**Rump steak** 0.6kg (Family)
**Rump steak** 0.6kg (Me)
**Rump steak** 0.7kg (Family)
**Rump steak** 0.6kg (Community)
**Fillet** 2.2kg (Friend)
**Rolled sirloin** 2.5kg (Friend)
**Rolled sirloin** 2.4kg (Family)
**Sirloin steak** x 2 0.25kg (Community)
**Sirloin steak** x 2 0.25kg (Community)
**Sirloin steak** x 2 0.25kg (Community)
**Sirloin steak** x 2 0.25kg (Family)

**Sirloin steak** x 2 0.25kg (Family)
**Sirloin steak** x 2 0.3kg (Friend)
**Skirt** 0.56kg (Friend)
**Mince** 1kg (Community)
**Mince** 2kg (Family)
**Mince** 2kg (Family)
**Mince** 7kg (Local community kitchen)

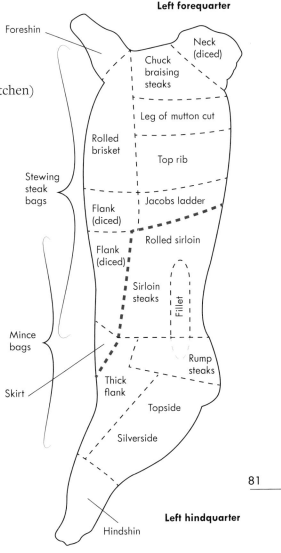

**Left forequarter**

Foreshin

Neck (diced)

Chuck braising steaks

Leg of mutton cut

Rolled brisket

Top rib

Stewing steak bags

Flank (diced)

Jacobs ladder

Rolled sirloin

Flank (diced)

Sirloin steaks

Fillet

Mince bags

Rump steaks

Thick flank

Skirt

Topside

Silverside

Hindshin

**Left hindquarter**

# FOOD STORIES

Over the course of a year, the meat that I butchered with John was sold, shared, distributed and enjoyed. The majority was eaten locally. Children had steak for after-school meals, chilli was served at Christmas parties and cottage pies were placed centre stage at family reunions. Sunday roasts were tucked into, both at the pub and at people's homes. Donations made to a local community kitchen were then served at fundraising events. I received photos and anecdotes of these occasions during the time I was taking the hide of Bullock 374 through the tanning process and into design, which brought unexpected moments of joy. Food is a great connector.

*IMAGES SHARED THROUGHOUT THE YEAR WHEN THE PRODUCE OF CHARITY FARM, BULLOCK 374, WAS ENJOYED BY FRIENDS, FAMILY AND THE COMMUNITY*

## SCHOOL TALK: NOVEMBER 2018

Cut: Sirloin steak, 0.6kg
Delivered to: Moreton Hall
Produced: Steak Skewers

I'd just brought home the leather from Bullock 374 when I was invited to give a presentation to A-level Art students at Moreton Hall, a local high school. I was told that some were considering further education in fashion design.

One of the hopes I'd had for keeping the meat was for opportunities like this, to talk about food and farming alongside a discussion about materials and design. I had thought about just bringing pictures of the breakdown of the carcass, and quickly decided against it. Instead, I asked the teacher if I could bring in a steak. This was an opportunity to connect the sensory experience of food with fibre, each of which had originated on a farm 12 miles north-east of the school. Some students, it turned out, travelled past the farm on their journey in.

As each student took a skewer of cubed steak, we discussed materials used in fashion and their links to other systems. The food and leather in front of us were tied to the landscape we were surrounded by. The conversations were very engaging. I reflected that as a fashion student I'd found it a challenge to see how the natural materials I was using could originate from rural farming and food systems.

Working forwards from Malcolm's farm in this way has provided me with a level of conviction and accountability. Leather had been presented to me as anonymous, but what I was beginning to learn was that, like food traceability, provenance is priceless. The knowledge broadened what fashion is, from an industry that works in a silo to one with the potential to reflect not only our relationship to clothing but also our relationship to food, land and nature.

*STEAK AND LEATHER FROM BULLOCK 374*

83

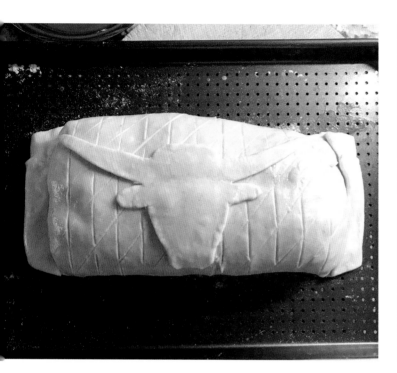

## FAMILY MEALS: DECEMBER 2018

Cuts: Mince, 1kg; Jacobs ladder, 2.1kg
Delivered to: Gillian Curtis
Produced: Mince Meat and Potato Pie, Slow Roast

Later, back in London and working on the collection, I received an email from Gillian. 'Hi Alice, we have recently enjoyed the mince and the Jacobs ladder from 374.'

I received the message while I was designing in preparation to make the collection. For the most part, this involved working on my own, which could feel lonely at times. Gillian's words brought me straight back to feeling part of something. She shared this with me:

'The mince was made into a meat and potato pie served on New Year's Eve with pickled beetroot. Forty-five years ago, our extended family used to host a huge party on NYE and my mother's contribution was meat and potato pies. Although I have to say I haven't replicated her grey pastry, I did make another pie on the same battered enamel plate she used to use.

The Jacobs ladder was cooked very slowly – it went into the oven at 100 degrees at 9am, well-seasoned, on a bed of shallots and covered tightly in foil. It was uncovered at about 5pm and crisped up at 180 degrees for 40 minutes. The rendered juice was removed and separated for gravy, made in the roasting tin. The meat was exceptionally tasty and tender served with jacket potatoes plus veg. The rib bones left after carving were made into beef stock, cooked in the pressure cooker for an hour or so with onion, carrot, celery and bay leaves.

We invited family to both meals (as we often do on Sundays). My 91-year-old father, my sister and cousins all came. On both occasions, our dinner table discussion was sparked by the provenance of the meat, it became about much more than nutrition and made us appreciate the meal more than usual. It also provoked memories and laughter, so I'd like to thank you for the opportunity to participate in this.'

BEEF WELLINGTON AT BARNWAYS 85

## A REUNION: JANUARY 2019

Cut: Fillet, 1.36kg
Delivered to: Sue Griffiths at Barnways
Produced: Beef Wellington

One meal was particularly special to me and happened by complete coincidence. The first delivery I made was to a house that was very familiar to my mum, but one I'd never stepped foot in. It was where my dad grew up and where my parents got married, and the lady who now owned it wanted to purchase the joint of fillet.

Mum and I were both invited back for Beef Wellington. The pastry was crafted to celebrate the Longhorn breed and cooked to perfection. It was an event that probably would not have happened were it not for the project. I hadn't imagined when John cut it from the loin that I'd eventually be eating it for dinner in my dad's family home.

*CANAPÉS FOR V&A MEMBERS USING BRESAOLA CREATED BY CHILTERN CHARCUTERIE*

## VICTORIA & ALBERT MUSEUM MEMBERS' EVENING: 20 MAY 2019

Cut: Silverside 5.8kg, 2.5kg, 3kg
Delivered to: Chiltern Charcuterie
Produced: Bresaola

In May, the exhibition FOOD: Bigger than the Plate opened at the Victoria & Albert Museum. Leading up to the opening, I knew I wanted to find a way to bring the produce of Charity Farm, Bullock 374, down to London and share it with guests engaging with the collection.

A suggestion made early on had been to create charcuterie. As I began researching how and where I could find help to make some, I came across Chiltern Charcuterie, a husband-and-wife duo running their award-winning family business in Buckinghamshire. Their website displayed sumptuous offerings of cured meats as well as a passion and respect for the 4,000-year-old history of charcuterie making.

I delivered all three joints of silverside to them. Each was marinated in red wine for a week and then cured with rosemary and pepper for a further two, before being hung to dry for six weeks. The event they'd be eaten at was an evening for members of the V&A. Canapés served there all reflected different produce relating to the FOOD exhibition.

While the canapés circulated in the courtyard, I displayed two plates on my stall alongside small pieces from the collection and a leatherbound book, all made from the hide of Bullock 374.

To capture people's responses to the project, I'd made a simple book. There was space to comment anonymously.

Name / Nationality / Dietary Choice / Response

Carnivore: Utterly delightful 'whole' experience, full respect for the beast.

Grumpy Vegan: So not vegan but I want it <3 What a very lucky Bullock.

Carnivore: Love the idea of respecting the whole animal.

#veggieforlyf (but ate your cow yum)

*CROWD-PLEASERS! CRISPY BEEF SALAD, HANMER DINNER*

## HANMER DINNER: 9 OCTOBER 2019
Cuts: Chuck 6.5kg, 5.6kg, 4.3kg; Hindshin 5.8kg, 5.9kg; Top rib 5.28kg
Produced: Crispy Beef Salad, Chuck and Shin Pie

As we approached a year since Malcolm and I had travelled to the abattoir, we took the opportunity to host an event. The exhibit was soon to close and I had people to thank for their involvement.

I arrived at the Hanmer pub to find blackberries and gooseberries bubbling in a large steel pot. They'd been picked by Annie that morning from Charity Farm and would make the crumble filling, enough to serve 60 guests arriving that evening. From the beginning, we'd had the idea to host a dinner and invite as

many people that had been involved in the project as possible. Local farmers, vets, Thomas's abattoir, John, the guys at the tannery, as well as people who'd bought produce and those who had been fed by Charity Farm for many years. Everyone implicitly connected to the collection of leather items that was down in London.

Although I was unable to bring the collection to the event, as the exhibit was still open for a few more weeks, I showed a presentation on how it had been created and had some small leather goods, along with the leatherbound book for people to write in.

Deciding the menu had been easy, we were down to the very last few joints and choices were limited. Malcolm had favourite dishes in mind. Food that was familiar, comforting and delicious. Malcolm then sourced the additional produce we needed to form the menu from local farms.

The room was bubbling with conversation. I thought back to the previous summer when I'd asked how I could work with a material that comes from my local food system. I realised I didn't know then what that really looked like. And it was there in that room. A community of people unified by food and those who produce it. The reason for the dinner was also to say thank you to Malcolm. For his willingness to teach, and share and connect – the way only a farmer can.

89

PIE MADE FROM CHUCK AND SHIN OF BULLOCK 374

## VICTORIA & ALBERT MUSEUM DINNER: 19 OCTOBER 2019

Cuts: Topside 4.4kg, 9.1kg; Rump 4.7kg; Foreshin 4.1kg, 4.7kg
Produced: Canapés of Beef Shin Kromeski with Oxford Sauce, Beef Tartare on Marmite Crackers
Starter: Cawl with Beef Dripping Toast
Main: Roast Topside with Parsley Mash, Wild Mushrooms and Grilled Onions

*The V&A exhibition FOOD: Bigger than the Plate asks how the collective choices we make can lead to a more sustainable, just and delicious food future. Together, designer Alice V Robinson and Head Chef of Michelin-starred eatery The Harwood Arms Sally Abé are presenting an answer in the form of this bespoke dinner for V&A Members. Using the final cuts from Bullock 374, Sally has created a menu inspired by Alice's work, challenging the notion of what is disposable, and exploring the journey of our food from farm to plate.*
Information from online ticket page.

There were 65 people for dinner, ten days after the event at Hanmer. These cuts truly were the last of the selection. A farmer who sells their produce directly had told me that shin and topside were often the last sold. While they may not have been the choice cuts, they were in safe hands. Sally Abé, head chef of a Michelin-starred pub in London, was in charge of crafting a menu from them for members of the V&A.

*LEFT: WELCOME CANAPÉS; RIGHT: GUESTS ENJOYING THE FINAL CUTS OF BULLOCK 374*

*ROAST TOPSIDE OF BULLOCK 374, WITH SEASONAL PRODUCE, AT V&A DINNER*

Sally's enthusiasm for celebrating British produce meant she was happy to collaborate on the event, and I was over the moon. The dinner would be one of many hosted by the V&A to provide opportunities to engage with projects exploring the possibilities of a 'sustainable food future'.

Alongside the tangible and embodied experience of food, I had considered ways to link farming and fashion for the guests. I was generously offered the services of Provenance to create a profile. Born out of a 'personal frustration for how little we know about the things we buy', Provenance is a digital platform for transparency, explains founder Jessi Baker. We'd met at the opening of the exhibit and I'd shared that making information about the produce and products of Bullock 374 accessible for people was a challenge. With Provenance, diners could view how their food had been produced and the provenance of the leather.

91

I hoped it would encourage a conversation around locality, transparency and the relationship between fashion and our food system.

# CHAPTER 4
# HOLD YOUR BREATH

My hunt to find a tannery began the day Malcolm called to say he'd booked the date with the abattoir. From my research, I knew that the hide of Bullock 374 could lie in salt for weeks, or even a number of months, if necessary. During that time, I was eager to gather options for processing in the UK.

In order for me to be able to work with materials from Charity Farm, the hide would need to be tanned and turned into leather. Britain has a long-established history in the craft of leather making. A Royal charter issued by Henry IV in 1444, now hanging in Leathersellers' Hall in London, attests to this. However, the UK leather industry has changed dramatically since then. During the sixteenth century, each town would have likely had at least one leather-making facility, with farms in close proximity as well as an abattoir. But, by the 1980s, there were fewer than 200 and today the total is 23. Inside the businesses that remain, knowledge spanning generations is retained. The value of this heritage continues to support sales of British leather into the global market, with 80 per cent of leather produced in the UK being exported. Across the country, the industry's legacy remains in street names like Tanner Street in London, near Fellmongers Lane, and in the quality materials still produced.

# TRANSFORMATION

Leather is by definition 'the hide or skin exclusively of animal origin, with its original fibrous structure more or less intact, tanned to be imputrescible…'.

The natural characteristics of a hide or skin set a baseline for the type of leather it can be made into. It is this complex fibre structure, or unique weave, that is stabilised through the process of tanning, creating leather. Holding the fibres together is the 'grain', the top of the skin that has faced the elements. It is the strongest part and the foundation that the fibres beneath are attached to.

Advances in chemistry and processing mean that creating leather is a collaboration of nature's ingenuity and human skill and intellect. As a result of ever-evolving tanning methods, the material can vary exponentially in its look, feel and performance.

There are two methods that dominate in the production of leather: chrome tanning and vegetable tanning. Today around 85 per cent of leather produced globally uses chrome tanning. Invented in the latter half of the 1800s, this method is considered the greatest advancement in leather making in its long

*DAY 1 – 09.44*

history. Through the use of chrome salts, a chemical reaction that accelerates the process: what previously took months is reduced to a matter of days. Chrome salts bind to the protein molecules and stabilise them. The resulting leather is strong, with a high heat tolerance (useful in making shoes) and an ability to bind with colour dyes (useful because it can create bright shades).

Before this discovery, leather was predominantly produced using natural tannins from barks, leaves, fruits and wood – vegetable tanning. Hairless hides are placed in pits holding a concoction of tannin-rich liquors. Over time, tannin molecules seep deep into the hides and envelop the collagen fibres, binding with them and halting decay. The colour of the leather produced will depend on the origin of the tannins used; the natural colour can range from pale pink from the bark of a mimosa tree to the reddy-brown of chestnut bark. Leather made this way will develop a patina over time and by reacting to friction and light, the leather begins to age and burnish, giving it depth and unique character.

Vegetable tanning reveals all the secrets in a hide. Every mark, scar, bite, scratch and growth line is framed. Part of the appeal of this tanning method is the look that it gives to the bare grain surface. The molecular weights of the tannins give vegetable-tanned leather a full-bodied feel, creating an honest and natural depiction of leather. This does not appeal to everyone, nor does it suit every application. Chrome-tanned leathers are often much more fluid and the grain surface can more readily used as a blank slate for building up an aesthetic, with colour pigments and resins. Both methods cater to the spectrum of wants and needs of different industries.

95

# HOLMES HALLS

After my day with John the butcher, I drove that night to Hull. I needed to arrive at the tannery early-doors as they were kindly allowing me to fit in with their production. For the next few days, I would watch the hide of Bullock 374 transform from raw skin into something more closely resembling a material I could work with.

I had been relieved after a month of searching to find a tannery willing to discuss processing the hide of Bullock 374. Of the remaining 23 tanneries in Britain, only six could process raw cattle hides (the preserved salted state that the hide of Bullock 374 was in). Each facility specialised in creating leather in different ways, some using a chrome and others using a vegetable tanning method. After much help from acquaintances in the industry, I'd exhausted all the possibilities of commercially processing my one hide using the vegetable tanning process. At that time, the existing companies were either unable to do it or in the process of changing hands.

I was desperate to transform my hide into something useful, a fact that was not well hidden when meeting Nick, the tannery manager of Holmes Halls. Nick had received my email and my plea for help and invited me to visit. The vegetable tanning route that I'd set out to take was a dead end. I'd had a plan but I needed to pivot.

Tanneries are complex places of manufacture, built to purpose. Precision is key and production needs to be consistent. Asking to have a single hide tanned and then returned to me was a logistical nightmare when hides look identical during processing, which is done in vast quantities. My request would only be possible if we had a plan to ensure the traceability of the hide throughout the tanning process. This required some consideration but, as I would learn, the leather

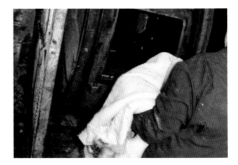

*DAY 1 – 09.27*                    *DAY 1 – 09.46*

trade is full of people with shared curiosity and passion. If you have an interest in the material, help will follow.

I arrived at Holmes Halls to a site steeped in history. Like many of the remaining tanneries in Britain, Holmes Halls has withstood revolutions and wars as well as the pressures of changing markets. The tannery, first established by John Holmes at the end of the eighteenth century, has evolved in tandem with the developments in leather manufacture. Two rows of wooden drums line the inside of the tannery warehouse and, within them, thousands of hides tumble around. This is one of the largest remaining facilities in the UK, producing and exporting part-processed, chrome-tanned leather. Here, salted hides arrive, are transformed and then sold into Europe.

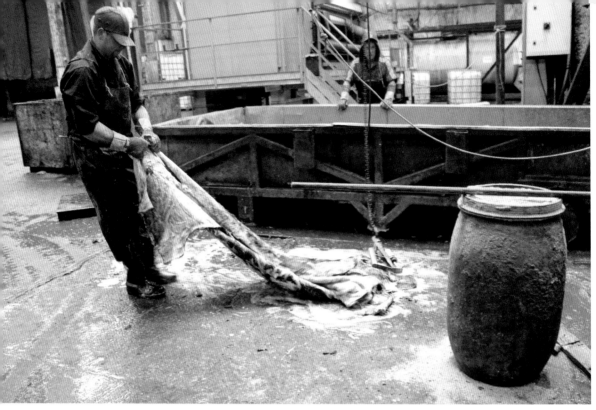

## PRE-TANNING
### Day 1: 30 October 2018

Our first day would involve taking the hide through the beamhouse, a collective group of processes which prepare the hide for tanning. The operations include soaking, removing the flesh, liming, dehairing, deliming and bating.

**08.49**

We begin in the tan yard. The hide of Bullock 374 is too heavy to carry from the car, so a forklift brings it on a pallet.

**09.21**

The hide is tipped onto the cold wet tannery floor. I am nervous that Nick may flag any issues with its condition. The hide has fallen to the floor with its hair side out. The brindle hair shines with rich ambers and brown, interrupted only by the finching of white tufts down the spine. It is the first time I've seen the hide laid out flat, hair side up. I notice that the white pool of hair on the breast extends all along the belly in a perfectly symmetrical stripe.

**09.46**

We are going to be using a small drum to soak it. This is the first stage of the pre-tanning process. Soaking removes all of the salt applied during preservation, as well as mud and muck. The aim is to rehydrate and clean the hide.

**10.49**

The hide has been soaking for just over an hour when Nick lifts the metal shutter on the little drum and water floods out. Suds pour onto his wellies. The froth swells, then drains away on the floor, but lingers on the hide.

**10.51**

The next stage of processing in this tannery would be submerging the hide in a solution of lime and sulphide. This strips anything that cannot be turned into leather from the hide, including the hair and epidermis. This solution swells the hide and also begins to destroy the hair, which would result in the hide of Bullock 374 becoming indistinguishable from the others.

Behind a massive machine, a metal skip brims with slippery hairless hides. The lime residue has made them shine like creatures of the ocean. In order to ensure traceability through the tannery, we have changed the sequence. 'Defleshing' would usually follow the liming process. With the hides still plump and slippery from the solution, they can be more easily fed through a

bed of revolving metal teeth. These teeth strip flesh from the underside of the hide. However, in order to keep the hair intact, we shuffle the stages, jumping from soaking to defleshing.

Usual production is stopped. 374's hide is lifted by a pincer on the end of a chain and carried up to the men controlling the machine.

Cylinders of teeth fan out from the centre of the machine. Two sets of blades are stacked, one on top of the other; their job is 'defleshing'. Squeezing through their mouth come the hides, flesh side up and then sucked back in, flipped over, then gently fed onto the machine bed, fleshless.

The spine of the hide is placed in the centre. As the blades fan out, they grip,

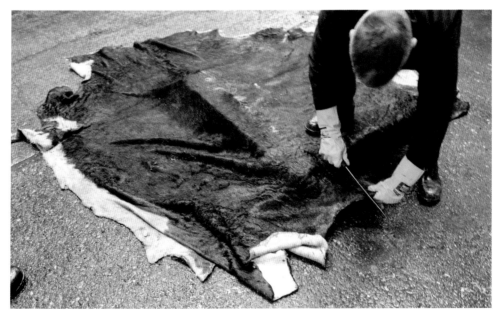

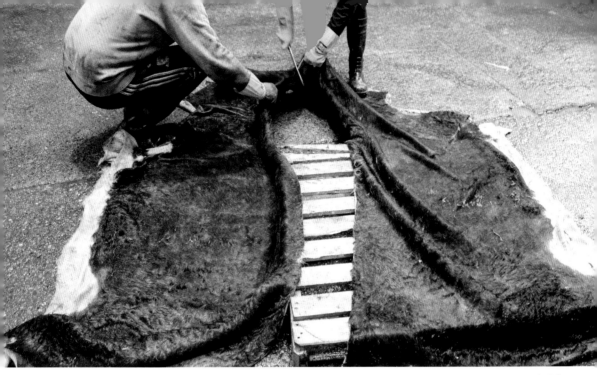

stopping the hides from flinging about and inevitably being destroyed. Going through this process after the hair has been removed means everything can slip through more easily, changing the process has been necessary, but is a risk.

I was told to get back to the front and watch it come through. I was told to hold my breath. No one could know for sure that it would work. There was a chance it could shred. Through the lens of my camera I watched, holding my breath; the hide slid, flipped and glided its way back down to waiting hands.

### 10.54

Now back safely on the floor, Nick takes a large knife to the hide and slices down the centre of the spine. The choice to 'side' the hide had been a part of the overall discussion of how traceability would be ensured throughout the tanning process in a facility with thousands of identical hides. In doing so, it would be the only half hide inside the tannery. One side would keep the hair on, and on the other, the hair would be removed.

### 10.55

A man came and flung a side over his shoulder, taking it to add to a liming drum of full-size hides. The hair-on side will join it tomorrow when they're put into a new solution. In the meantime, Nick puts it back into the small drum for an overnight soak.

The day is over for me, and it's not even midday. The cycles in the tannery are long and run through the night. During that time, recipes are followed, stimulating a chemical reaction to take place inside the drums and alter the hides.

## TANNING
### Day 2: 31 October 2018

**08.40**

I arrive back at the tannery, ready to move the hides onto the tanning stage. One side has had the hair removed, but the colour still remains. The white pooling of hair from the chest to belly can be seen, even though the hair has gone. The hide gets added to a de-liming drum. We wait a few hours until the hair-on side can be added.

**08.48**

We pull the hair-on side of the hide out of the small drum and set it onto the pallet, ready to be lifted over to the large wooden drums.

I had been apprehensive about this next part, the tanning. Chrome is a metal. While it has merits in producing leather quickly, the effluent, if not treated correctly, can be toxic. In some parts of the world, a lack of infrastructure to safely treat effluent has had a devastating impact on workers and communities. Driven by a desire to have materials made quickly and cheaply, leather production has come at the expense of human and environmental welfare.

On my first visit, I was given a tour by Nick. He showed me the sophistication of the tannery's water filtration system and how different solids and oils extracted from the hides during

101

*SIDED HIDE OF BULLOCK 374*
*LEFT: WITH HAIR REMOVED*
*RIGHT: WITH HAIR INTACT*

into overdrive. I realised that pulling the hides out was not an option. One side was currently swimming around inside a drum packed full of hides. We couldn't fish it out. The drum would not be emptied until tanning was over.

This was my only commercial option for tanning and for that I was incredibly grateful, but it felt at odds to be focused on the positive impacts of agriculture and yet not be able to adhere to those values throughout production. I had to remind myself of what I was trying to do, which was learning. Learning what questions I wanted to ask about the materials I was working with and beginning to understand the complexities of these decisions.

Why had this method of tanning become so popular? It is cheaper, more versatile and quicker than other tanning methods. It meets the needs of the voracious industries that use the finished materials. What would be the consequences of doing it differently? Both from a production and finished quality perspective. I resolved that feeling a sense of accountability for these decisions was a part of the process. It was the double-edged sword of transparency.

**11.50**
The final stages of preparing the hide for tanning involve bringing down the pH of the hide from above 12 during the liming process to around 7.5–8.5. Doing this reduces the swelling of the hide.

the leather-making process could be captured and repurposed in other industries, such as oils for manufacturing and nitrogen-rich solids for fertiliser. Residue of unspent chrome could then also be repurposed to use again. This was in place for both environmental and human safety, strict regulations were adhered to and audited.

My apprehension about using chrome for the tanning method extended to the impact it has on the finished leather. The metal content would impact compostability. While leather tanned with chrome can biodegrade, the toxicity of substances remaining means it fails to meet the specification of what is defined as compostable by the EU. I had laid awake and considered asking for the hides to be pulled out and not tanned. Dramatic as that sounds, being so close to the decision-making pushed my mind

De-liming agents are used to remove the products used during the liming stages which still remain in between the fibres in the hide.

The pH is checked before the hair-on hide is added. The last preparations are bating and pickling. They make the hides pliable, clean and ready for tanning. Enzymes are used to remove unwanted proteins from the hide. Stripped of all other components, the hides are sheets of collagen, primed for transformation.

**11.52**
Happy with results of the pH tests, the hair-on hide is added to the drum. These will stay in for just less than 24 hours, the water will be changed and new solutions added until both sides are in a stable tanned state. I'll come back tomorrow and see.

## Day 3: 1 November 2018

**08.49**
Today the sides will be at the stage called 'wet blue' – a sort of limbo, a stable

middle stage of leather production. In this state, the sides won't decay, but if they completely dry out, they will become stiff as wood and it will be impossible to continue processing.

**09.19**
Each side is put through the 'sammying' machine, a set of two huge rubber rollers stacked on top of one another that squeezes out their moisture. This is the first opportunity to see what has been hidden under the hair. Surface and mechanical defects can now be detected. At this 'wet blue' stage, hides can be graded based on the severity of these defects. Sold in volumes, this ensures that a tannery will be purchasing a quantity all of a similar standard. The resulting leather will then all be of the same quality.

They'll stay in a semi-dry state until they're re-tanned. I load them, wrapped and damp, into the back of my car.

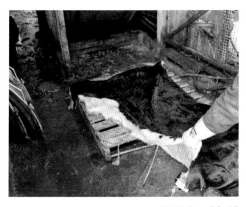

*DAY 2 – 08.48*

*DAY 2 – 11.52*

# PITTARDS

It's been two weeks since I left Hull with the sides of Bullock 374. They're now at home, under the watchful eyes of my mother. She tells me normal daughters just leave washing, not half-processed leather. The two sides of the hide are a stark contrast to each other. Information of life is found in the hair; evidence of life is what is seen on the skin. They are both rolled up and sealed to keep the moisture in. I didn't have a chance to see them properly at Holmes Halls, but now up close I can see some scratches and bites disturbing the smooth pale blue surface of the rolled-up side.

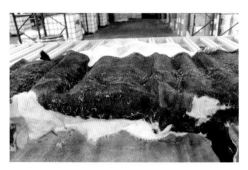

*DAY 1 – 12.40*

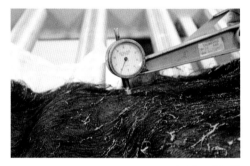

*DAY 1 – 12.46*

## DRESSING
### Day 1: 20 November 2018

It's just past midday when I arrive at Pittards, a tannery in Yeovil. Founded in 1826, the historic tannery is where the final stages of leather production will take place. When I leave, I will have finished leather made from the hide of Bullock 374. But at this moment, I have no idea what that material will look like.

This morning, I've come to see industry expert Robert Painter and begin the next stages of production. By following a series of processes, often called 'dressing', the leather will become a uniform thickness, flexible, soft and tailored to suit an end product.

**12.40**
We unravel the two sides onto a conveyor belt with metal rollers. Released from its casing, the hide still holds creases from being folded. Like dried plaited hair, they are crimped, but once wet again, they will flatten.

Both sides of the hide are still full of substance. Other than removing the flesh and other properties from the hide that were necessary to strip before tanning, the hide is still as it was when removed from the carcass of Bullock 374.

**12.46**
For the first time, a gauge is used to measure the thickness. A long contraption with two arms pincers the hide and then takes the measurement:

6mm. We must know this measurement before we begin, as from here on in decisions are made to the closest 0.5mm.

The sides still don't resemble any leathers I've worked with before. At this point, the side without hair, in particular, could be manipulated in a multitude of different ways. Each decision could affect the eventual look and feel of the finished material. I needed to answer the question, 'So what are you planning on making?'. Leather bags are usually made from leather that is around 1.4–2.5mm thick, shoes around 1–1.8mm, while belts and straps are anything from 2–6mm. We decide to split each side in half, through the depth.

We carry the hides to a huge contraption that looks like it belongs on the inside of a spaceship in an old sci-fi movie. It is raised high off the ground. A huge knob is turned and its clicks increase the number on the only digital interface on the machine. Information displaying the thickness that we have chosen to take from the top of the hide is dialled into the machine.

**12.53**
The settings have been adjusted so that a revolving band knife will slice in between through the depth of the hide. Both sides of the hide of Bullock 374 are pushed, one at a time, through the splitting machine. They are eased in slowly. Spreading out the hide as it is slowly sucked into the machine and keeping it flat is of paramount importance to ensure that the knife splits it evenly.

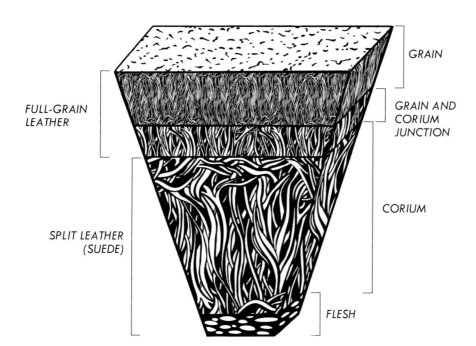

FULL-GRAIN LEATHER

SPLIT LEATHER (SUEDE)

GRAIN

GRAIN AND CORIUM JUNCTION

CORIUM

FLESH

Out the other side, the top of the leather is carried up and over the conveyor belt, beneath it the under layer is spat out. The side with the hair on is sucked through first and the underside collected, then the side showing the top grain. I now have four sides, one with the grain, one with the hair, and two 'splits'.

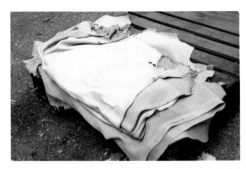

DAY 1 – 13.02

### 12.54

We move along the line of specialist apparatus. The four sides are carried towards a shaving machine. From the centre of the spine to the belly, and from the neck to the butt, the thickness of the hide varies. Although we've split it with as much precision as possible, a shaving machine ensures it is levelled throughout all points of variation.

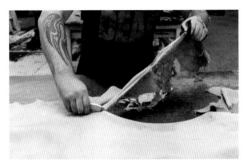

DAY 1 – 13.14

### 13.02

All sides have been shaved and they are folded on a pallet.

### 13.14

Thin pieces of the hide are cut away from around the belly and legs on the rounding table. In these areas, the hide is too thin to create usable leather.

### 13.19

The total material we now have to use from the hide weighs 28kg. This weight will help create the recipe for the 're-tan'. I've asked if it can be re-tanned with bark extracts, vegetable tannins. This is called a 'combination tan'. Tannin molecules act as stuffing for the hide, filling in between the fibres. The result, we hope, will be a leather with some body to it.

The hide can finally be soaked in water. The purpose of this stage is to add properties to the leather such as suppleness and colour. By using specialised chemistry, the overall performance of the finished material can be enhanced. Importantly, without the absorption of fat liquors and oils, the leather in this current state will dry stiff. Historically, natural oils and fats would have been rubbed into hides and skins to give them the necessary softness to be worn or used. Stretched tight over a wooden stick, each hide would be pulled back and forth energetically to loosen the fibre structure, but we'll be using a mechanical method to help with that. There is not much left for me to do other than wait.

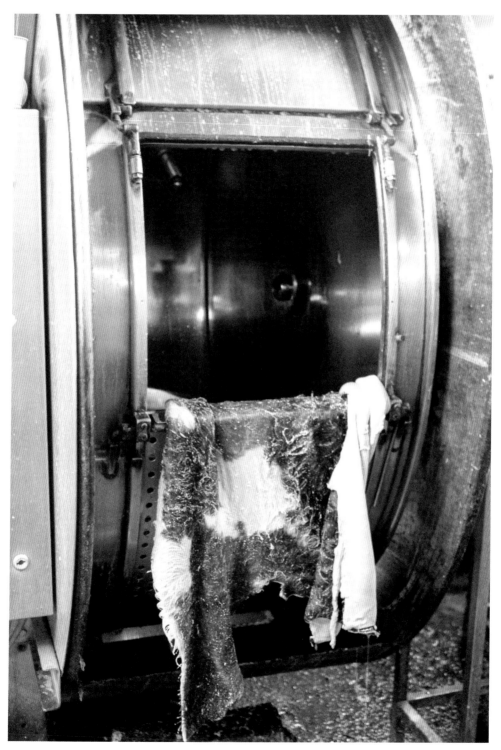

*DAY 1 – 17.07*

## Day 2: 21 November 2018

**09.57**
Robert has already arrived, pulled the sides out of the drum, and flung them over a wooden horse. These structures are the most gorgeous embellishments to the tannery, a secondary fact to their primary importance, which is to hold stacks of leather efficiently. All around the tannery, triangular prisms with flat curved tops and narrow bases have leather laid over them and liquid draining down the sides. One is taken up by the hide (four sides) of Bullock 374, although it could hold far more. Pulled up alongside it are two with towers of dripping leather, stacks of at least 40 hides. Robert is happy with how the tanning has gone, but the sides need to dry before we can really tell. We wheel the wooden horse around to a machine that will reduce the water content in the sides. It is similar to the sammying machine at Holmes Halls. Four sets of hands spread one side at a time. The leather doesn't want to lie flat; it takes force to ease out the volume. Hands quickly encourage it to flatten as it is pulled in between the squeezing rollers.

Both the full grain and the two splits can now be put into an industrial dryer. Two layers of metal close upon one another and suction the liquid out until it has evaporated. We lift them dry and crisp.

**10.16**
We can't dry the hair-on side the same way as the hair would frazzle. It needs

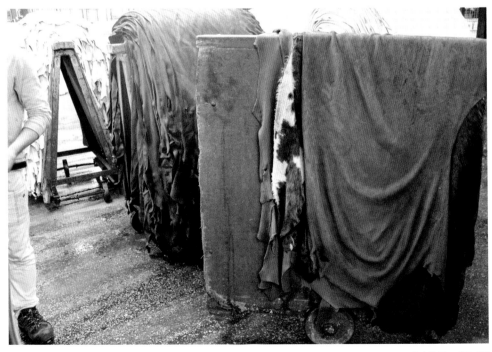

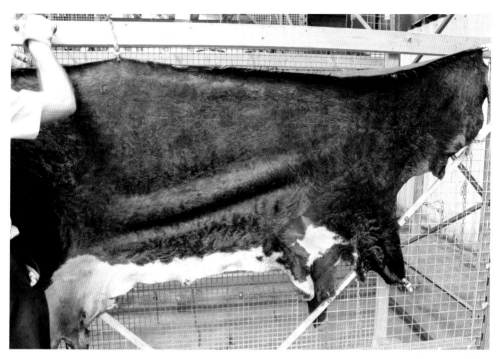

*DAY 2 – 10.16*

to dry naturally on a toggle frame. I've never seen anything like it. The tiger-stripe bridle is more pronounced than ever and it is heavy and full. As the hide is wet, it needs to be set into a position to dry; we have to be careful not to stretch and disfigure it. Robert expertly mounts the hide onto a large sheet of perforated metal. He pulls and clips the side with the right amount of force.

At this point, the fibres inside the hide are tense and need relaxing. To do this, they are put into a large tumble-dryer-like-drum and are milled. The weight of the leather pieces bashing on top of one another and the turning of the drum slowly loosens the fibres, making it more fluid and giving it drape.

Once the splits have been softened from tumbling, the last job is to turn them into suede. This was the biggest surprise to me, something I hadn't anticipated would be yielded from the hide of Bullock 374. The blade that sliced the sides into two pieces divided them through part of the skin structure called the corium (see page 105). This section of the hide has the loosest fibre structure. It is porous and weaker than its counterpart, which contains the full grain. The full grain is strong in its structure, as it's the surface that faced wind, rain, bites and scratches. The split layer was the part of the hide closest to the flesh and carcass.

109

**13.09**

We run the two split sides that have been softened from the drum through a machine that is essentially a huge roll of sandpaper, revolving at turbo speed. Careful not to apply too much pressure, the side is dipped in and out of the mouth of the machine. Each time a brush is swept over the surface, the nap becomes finer and finer. It is wonderful to watch. Slowly the leather is teased in and comes out more luxurious than before. Eventually, confident it will not be shredded, the whole side is fed through and, carried out on the conveyor belt the other side, comes sumptuous suede.

We are done. A great sigh of relief is released from Robert and me. Anything can go wrong at any stage of the leather-making process, through human or mechanical error. The total expanse of leather created has been doubled; I have approximately 20–23 square feet of leather, and 20–23 square feet of hair-on leather, and around 30–35 square feet of suede.

All three materials reflect a type of leather that I was accustomed to using. Together they represent the true materiality of Bullock 374. Here, before me are limitations, guidelines, a boundary to design within.

DAY 2 — 13.09

DAY 2 — 13.10

*DIFFERENT TEXTURES OF THE LEATHER AND SUEDE*

# CHAPTER 5
# A MONTH OF MAKING

*EMBOSSED LEATHER OF BULLOCK 374*

I'd gone into battle with a beast. A design battle, every move I made was met with a surprise, something that stopped me in my tracks, forced me to rethink, and each time resulted in putting down my scalpel and retreating back to the literal drawing board.

When I got home from the tannery, I laid out the four sides of leather on the dining-room floor. Their vastness swallowed our small cottage room. At that point, I couldn't imagine ever having the conviction to cut into it.

There is no going back once leather is cut, a fresh blade will slice through a hide like butter. Unlike woven fabrics, leather is unforgiving. There is little stretch or ease if you miscalculate by a couple of millimetres. Instead, millimetres are the measurements you work in, each one a deliberate design decision. And Bullock 374, the Longhorn Limousin cross from Charity Farm, provided me with only so many millimetres to work with.

I laid the long edges of the full-grain and hair-on side next to each other and the hide became whole again. This was my first opportunity to take a closer look at the leather.

Kneeling on the carpet, I brushed my fingers over a group of scars gathered at the shoulder of the full-grain side. I couldn't feel them. They must have healed long ago. They were short and dashed in different directions. I thought of the dead spiky tree next to the shaded oak, the thorny hedges that line the fields and the barbed-wire perimeter of the fledgling woodland at Charity Farm.

# PROOF OF LIFE

On the main body of the leather, I found evidence of bug bites that had healed into a pinch on the skin. Towards the legs and belly, the surface of the leather changed slightly, as did the feel. Cracks and puckering created an irregular mottled effect. Striding legs had loosened the fibres and made space for these creases to form. Above the furrows formed by the back legs were more scratches. Longer and more pronounced. Something must have really caused an itch. From the neck, through the body, to the belly, the consistency of the leather changed, each part a reflection of the life that was Bullock 374.

Technically, I had skipped a critical stage of the leather-making process, the 'finishing'. In industry, this stage would come last. Once dry, a range of methods are used to create the final aesthetic and durability of the material. Depending on the level of protection and standardisation desired, the surface can be treated with colours and coatings. As a result, the performance and look can range enormously, from leather able to withstand spills of wine or the smearing of a jam sandwich to leather which changes over time and exhibits signs of wear.

The evidence of life that I found in the leather of Bullock 374 is often charmingly referred to as 'natural character'. These marks can remain evident in finished leather, hidden, or removed altogether. Leather with the surface grain intact is deemed higher quality – a material style often preferred for high-end leather goods. Having a hide littered with natural character, however, is not a commercially accepted luxury aesthetic.

The full-grain leather before me was unabashedly imperfect. Almost everything about this side was a contradiction to the lived education I'd received of what high-quality leather looked like, the bags I'd seen in Sloane Avenue's shops, for example. A material that looked like this would most likely have been demoted to a lower grade and the surface would be 'corrected'.

Buffing the leather removes some of the grain, taking with it these surface-level defects. As a blank slate, a new surface can be created in its place. Substances can be applied by spray or hand, sealing the exposed grain and protecting it from water and abrasion.

This new coating can then be adapted in various ways. Heated metal plates can emboss or deboss patterns, smooth out the surface or add shine. Endless designs can be pressed into the leather, from graphic and abstract to ones

that emulate the natural characteristics of full-grain leather, just consistently this time. These methods make it possible to ensure that products sold on opposite sides of the world look identical, an important requirement for mass manufacture but an unrealistic expectation for leather to meet without this assistance. The reality of natural character in leather and the perception of quality leather in luxury goods is therefore a challenge, one that stems back to the raw material.

I'd chosen to leave this leather bare in order to learn about its natural character. It was impossible that its surface would be blemish-free because of the outdoor grazing environment Bullock 374 had experienced. I could not grade this leather. My grading had been Charity Farm. This leather had been made from a raw material that was produced by that food system. By leaving it bare, I could attempt to construct for myself new codes of quality on the basis of those origins.

*SCRATCHES ON THE LEATHER'S SURFACE*

# IMPERFECT BEAUTY

The contrast of the hair-on side that lay next to it was stark; its uniqueness needed little interpretation. The hair had retained all of its natural kinks and swirls. Down the spine, tufts of white finching remained and long white hair spun out from a now halved whorl.

For the first time, I could see how the hair began thick and long down the spine. It glistened, fanning out from the whorl stretching along the centre of the hide. Gradually the hair thinned and shortened, as it grew closer to the belly. Around both of the legs, the hair turned to waves, rusty shades caught the light, making them glow brighter. A white strip stretched from behind the front leg in an almost straight line before tapering to the hind leg. Only one inky drop of brown broke the pearly expanse. I felt then that I understood why farmers often wanted to preserve the hide of their favourite animal with the hair on. It was far from a trophy. The preservation of the living animal was confronting and humbling.

I thought back to the tanneries I'd visited and the pallets of hairy hides folded in stacks that reached up to the ceilings. How visceral it was. Leather is an emotive

*BRINDLED COLOURING OF HAIR-ON LEATHER*

material. A fact that, when stripped bare and reassigned a more agreeable aesthetic, had at times felt lost on me.

*A NICK IN THE SUEDE*

The hide of Bullock 374 had been thick. I am told this is a trait of native breeds as their hides have adapted to protect from cold winters outdoors, and of cattle which have grown used to their natural habit. Each piece of suede was slightly smaller than the side it had been cut from. Edges had been trimmed away as they became too thin and fragile to work with. Laid flesh side up, I brushed the nap back and forth. The fibres were finer towards the spine and heavier towards the belly.

Then I saw a nick (see image above). A cut had perforated the skin. It hadn't been made in the tannery; the angle of the slice suggested it had happened when the hide had first been removed from the carcass. In its raw state it had gone undetected. Removing the hide by knife at the abattoir had jeopardised its potential uses further along the leather supply chain – the use of the machine hide puller would have lessened the chances of knife marks occurring in the finished leather. Fewer knife marks meant a higher likelihood of an undamaged hide. Less damage meant a higher-quality raw material for a tannery.

That cut would affect the cutting yield of my material slightly. I would have to plan my designs to make sure that the cut did not affect the appearance or function of any item I made, but I could work that out. A benefit of letting the material lead the design process but, in reality, provenance does not trump such practicalities.

I began to understand that leather was assigned its value in far-reaching ways, from the evidence of life left on the hide to the way in which it had been removed. As a raw material, its value is assigned largely with an understanding of what the material could become and what market would want it. Did it have the potential to conform to a designer's desire or a customer's demands? Considering the material based on its provenance as a product of an agricultural system meant that I needed to accept, work with, frame or reframe this character and celebrate its value.

# GETTING STARTED

'We have to start on Monday, otherwise you'll never make it.' It had taken weeks to get to the point where I thought I could make the first cut into the leather and, even then I wasn't sure, but I was running out of time. The exhibit at the Victoria & Albert Museum opened in a matter of weeks. Over the phone, the all-knowing, never-flustered, meticulous leather worker Stephanie gave my fearful self the kick I needed.

If I were to list the things that I am most grateful for from my fashion education, high up on it would be that I was given the opportunity to meet Stephanie. Not only are her skills and knowledge a precious resource, but they were also essential to me (and other students) learning how to design with and from leather. I packed up my designs, all four sides of the leather, and headed to her studio.

Before returning to London, I had tucked myself away in Mum's dining room, which I'd rearranged into a makeshift studio. I'd created templates of the full-grain, hair-on and two suede sides on long sheets of pattern paper.

Each contained squiggled outlines marking the extent of Bullock 374's hide. Inside them I mapped the prominent characteristics of each side. I marked cuts and scratches and noted where the internal fibre structure had created a different look or feel in the leather. The total amount I had to work with was around 75 square feet, the expanse felt intimidating, and yet, at the same time, inconveniently restricting.

This restriction made a necessity of considering what 'waste' would come from designing items out of this leather. Approximately 15 per cent of textiles intended for clothing end up on the cutting-room floor. Techniques to reduce waste in garment making have been explored for centuries. In both the Japanese kimono and Indian sari, linear designs utilising an entire textile piece make best use of precious materials and, as a result, interesting shapes, lengths and gussets are created. A premise of zero-waste pattern cutting is to minimise waste by using the right material for your designs.

As the materials produced by Bullock 374 were my starting point, I needed to try to understand what they were best suited to create and let that information lead my design.

# COLLABORATION

'Leather has a 3D memory, if you cut the shoulder of a cow, it will return. The power of the leather is stronger than the will of the designer', words imparted years earlier by a production manager at a luxury Italian manufacturer, a warning that still rang true. 'We roughly throw away half of the leather we order, because of the way in which we need to cut the specific pieces.' I thought of this as I looked at the hide. It was evident some sections had more consistency than others and these areas only extended so far.

Before I could design, I needed to consider how the structure of the leather changed within each side. Often in leather production these changes in fibre structure are distinguished by dividing the hide into sections, most commonly by the shoulders, backs (bends) and bellies, as each have a distinctively different feel.

I had previously seen these sections cut off before the tanning process began. First to go was the belly. A continuous vertical strip cut from the side of the

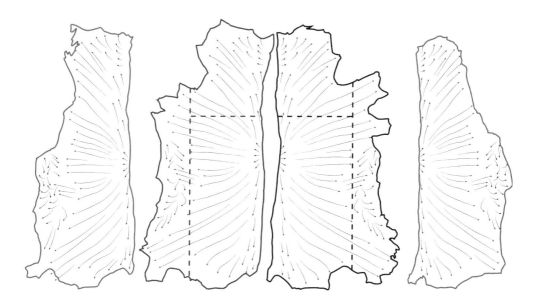

*HIDE FIBRE DIRECTIONS: FROM LEFT TO RIGHT: SUEDE LEATHER; HAIR-ON LEATHER; SUEDE* 121

hide. Much like our bellies, it is softer and looser than the rest of the body. This sort of fibre structure makes it more susceptible to wrinkling once in the form of leather and so is less suited to applications where it may need to be stretch resistant.

With the belly removed from either side, the hide begins to look more rectangular. Next to be separated is the shoulder, a horizontal division across the upper half of the body. Less dense in its fibre composition and sitting at the base of the neck, it is more flexible because of the head movements. Its consistent thickness makes the shoulder easy to work with and a popular part of the hide for bag making.

The piece that remains is called the butt – or if split again down the spine, each piece is called a bend – it has a tightly compact fibre structure making it the strongest and most consistent part of the hide. It is also the largest cut, almost rectangular apart from the bottom end tapering in the centre where the tail once was.

*DESIGNING AND PATTERN-MAKING: A GROWN-ON COLLAR AND BAG GUSSET*

# COLLECTION PLANNING

With all of these considerations in mind, my collection couldn't be dictated by what I may have ideally liked to design. Certain items were out of the question because the leather wouldn't be suitable for them. The leather Bullock 374 had produced was heavy in its drape. I could not design items like leather trousers, shirts or skirts. To create those items successfully, the tanning recipe would have needed more consideration or perhaps I would have needed a different raw material entirely.

The volume of leather I had to work with also provided design constraints, sweeping floor-length dresses were out of the question. I'd need to design items that all had different functions and style, and make sure that when it came to cutting from the leather to make them, my patterns made economical use of the leather. The task quite honestly had me terrified, it was the one part of the journey I had a real say in, and I therefore procrastinated for weeks.

I arranged images of products and separated them into categories that offered different functions, pieces that complemented one another and sat coherently as a collection but didn't compete for function. Flat shoes, heeled boots, sandals, large overnight bags, tote bags, bum bags, long coats, short jackets, gilets – items this type of leather was historically well suited to but that sat in separate product categories.

Many of the construction techniques used for the products in the images I'd gathered were ones familiar to me. There were tailored set-in sleeves and winged collars. There were bucket bags with large circular bases, barrel bags, briefcases with long inset gussets and narrow T-base totes. I could envision what some of the patterns to create those designs would look like and worried that the pattern cutting would be too wasteful. Instead I considered designs that could save me space. Features such as grown-on collars and bag gussets that required no seam allowance.

Nesting, the process used in the industry where patterns are placed inside the material to see how many can fit, is done once the design is decided. Programmes have been created so that yield can be maximised through the genius of jigging and rejigging patterns to be most economical. I'd combine that approach with designing from the material in front of me, in an attempt to utilise the leather well.

# PROVENANCE

A perception of beauty can morph into an unreal expectation of something that is inherently natural, as well influencing our tolerance for imperfection. In leaving the leather uncorrected, I wanted to learn how these inconveniences might affect my approach to design.

But it was a sensory connection to the story of leather and its origins that I'd been looking for. I wanted to see the leather for what it was – a bare skin that showed life and its flaws.

The full-grain leather part of the hide contained the most evidence of imperfection. While the hair had covered all traces of scratches, growth marks and bites, with the hair removed they were unmistakable. I took a natural wax plus a soft cloth and began to rub. Instantly the leather began to shine and through the grain a mixture of tones developed. Growth marks at the neck and wrinkles at the belly became ever more pronounced.

The leather, the extent of it, and its existence was tied to Charity Farm. For me, the provenance of Charity Farm formed the embedded value of these materials. As this value was intangible, I decided to create stamps that carried information about Bullock 374 and Malcolm's farm. I would also brand the items I created with this number, the date of slaughter and the postcode of Charity Farm: 374

*GROWTH MARKS ON LEATHER OF BULLOCK 374*    *FARM ORIGIN AND LIFE STAMP*

09.10.18 LL13 0BW would be marked in quiet places such as the lip of a coat pocket or on the inside facing of a bag.

The collection would be made up of a coat, jacket, three pairs of shoes and two bags. From whatever was left, I'd make small leather goods and design them as I went. Instead of debating the length of a jacket, I would fill the entire width I had to work with. Decisions that probably would have taken me hours to come to were dictated for me. A long suede coat with a grown-on collar, three-quarter length sleeves on a boxy jacket, knee-high boots, bags that filled the entire neck portion of the side I had to work with.

As I designed the bags and the shoes, their lengths would increase and decrease accordingly. Fold, tuck and loop. Minimal manipulations to try to create a 3D form. By placing the pattern for the bag at the neck, the growth marks could flow across the body and slowly fade as they journeyed from the opening, travelling down and under to the back of the bag.

The gussets could form the main body of the bag and then flip 180° and be stitched so that the tabs could then hold the handles – everything folded, rolled or tucked back under the body to attempt a feeling of flow. Scratches and bite marks dashed across the leather. Having limited space meant I could not frame them or choose their positioning entirely.

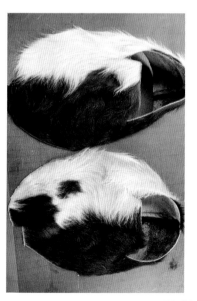

*DESIGNING WITH THE DEFINING FEATURES OF THE HIDE IN MIND*

# BONE AND HORN

We drove the shovel into a patch of earth that we'd marked with a stake. The horns have been buried since the day we'd gone to the abattoir six months earlier. I'd left them as long as I could. Careful not to drive the metal straight into what lay beneath, my uncle rolled the earth away and I dug to find them.

We blasted them with water, unsure of what would be revealed. As the soil came away, their shape became more distinct. The slight curve of horn that was beginning to form, tapered from a thick cylindrical base to a fat round tip. As pressure and moisture continued to pummel the horns, their creamy exterior broke in places. The small amount of horn I needed to get to was hidden under a layer of soft, horn-forming tissue.

*WASHED HORN*

*CLEANED AND SANDED HORNS*

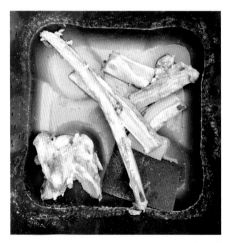
*PRE-WASHED BONES*

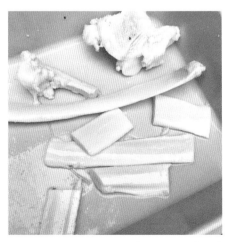
*WASHED AND CLEANED BONES*

Picking them up and drying them off, we noticed that the inside bone core had not loosened at all. We'd buried them so that the connective tissue between the horn sheath and the bony core – a pink mass that grows up into the horn – would decay and dislodge.

We rolled them around in our hands. The ever-so slight curve of the horn means that the bony core cannot slide out. We'd have to cut them in half. The cross-section looked like all of the diagrams I'd seen online: a pink core and soft forming exterior and between the two, a faint cream line of hardened horn.

These were not the fully developed horns that suit being fashioned into vessels to drink from. These were short, and the small amount that I could work with was buried under a layer of tissue that began to break away as I picked and scraped. Once, even the slightest piece of horn would have been of value. In a world before plastic, horn was used for buttons, spoons, jewellery and hair combs. I would not be doing anything quite so elaborate and I currently had no clue what I'd be left to work with. After hours of scraping, I realised the piece I'd begun with was a quarter of the size but I was beginning to determine where the pearly horn was that needed excavating.

Weeks later, sitting on the cold patio floor, I huddled around a steaming bowl of boiling water, and cleaned the bones. From the pile that had accumulated during my day with John, I'd kept ones with the most obscure grooves and curves, ones with a scale that suggested their origin.

My plan was to make hardware. I could have designed bags and jackets that did not need features such as buttons or clasps, but the bones, like the horns, would provide information about the materials they were looped through and sat upon.

After they were cleaned, I prepared them for a process called electroforming. Once copper had grown over the surface, they were then plated in white rhodium. This was to ensure the hardware wouldn't react with the leather. Each was engraved with the number 374.

# FINISHING

With the outer shells of the pieces that made up the bulk of the collection designed, we could focus on cutting the linings, and designing small leather goods using the leather that remained.

A purse was added to the collection that was constructed from the full-grain leather, suede and hair-on, as well as two card holders and two small hair-on bags which could be slid onto the suede coat belt.

During those weeks of designing and making, accidents happened and our plans had to change. The first came with a pocket bag. For an unknown reason, hidden among the hair, one half of a pocket bag got shredded. With each inch of material finite and precious, and each design decision affecting another, a casualty was always going to be an inevitability. Understanding the knock-on effect felt like a blow. Instead of four pocket bags with hair-on, we would now just make two and borrow from other 'splits' that had come from the suede to take its place.

One night when working late, we were forced to pivot again. Stephanie and I were both tired but wanted to finish the shell of the suede coat before I left that evening, so we could move onto the sleeves the next day. As the front of the coat was lifted from the bed of the sewing machine to the studio table, a great big splodge of oil began to seep before our eyes into the centre of a front panel. Smack-bang in the middle. Everything had been cut for the outer shell and all that was to be decided were small additional details and facings. This ruined everything. We called it a night and I cried on my way home.

The next day, I spent hours searching for a cleaner to help. It turns out, oil famously causes permanent damage to suede. I needed to get a grip and cover it up with something. Laying what we had left of the suede side out on the table, we started with the shape we'd ideally like to use for the flap to cover the stain, and then, again, shrank our expectations accordingly. A small flap could be added to the coat and it would skim just below the oil. The coat pockets would have to be smaller but, in the end, I think aesthetically it was an improvement and the parameters I had to work in had made the decision for us.

Finally, bags were given hand-stitched handles and coats had horn and bone buttons. The collection was coming together, but all three pairs of shoes remained sole-less. I hadn't been able to produce sole leather during the

production of Bullock 374's hide and didn't want to introduce other leathers to the collection. Instead I used a method of bonding leather with rubber. Having created silicone moulds of the outline of each shoe, I poured in a mixture of leather shavings and rubber. These would make the sole of the shoes.

Many of my choices had been made for me. With each piece that was made, the material extent of Bullock 374 was slowly being translated through my interpretation of fashion. It was not a true representation of the total materiality because to have that I would have needed to keep the hides whole. As pieces of the hide were cut away and reassembled, they left one world and entered another. Evidence of Bullock 374 dwindled as each separate piece was set aside and placed into boxes ready to take to the V&A. Small clues would make up a greater image when they were reassembled as a collection but, for the time being, each had a stamp that carried an identity from the field forward.

I delivered Collection 374 into the gloved hands of the Victoria & Albert Museum staff. The journey was complete and Stephanie and I both got a good night's sleep.

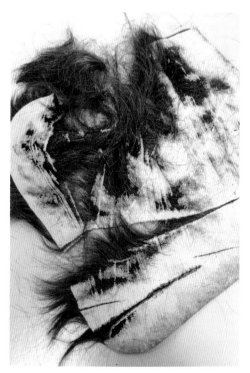 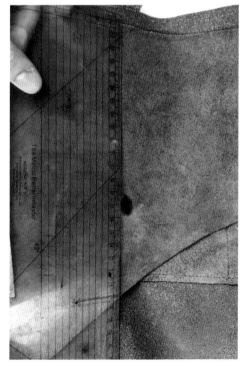

*STUDIO CASUALTIES: POCKET BAG RIPPED IN SPLITTING MACHINE; OIL ON SUEDE COAT*

# THE COLLECTION

### 1. COAT

• Suede, leather belt, suede facing, leather tab, bone and horn buttons.
• Boxy fit, raglan sleeve and grown-on collar, with vent, flap and jetted pockets, length as long as would fit.

### 2. LOW-HEELED MULES

• Suede, leather insole, wrapped wooden heel, leather offcuts embedded in rubber soles.
• Utilising the gap left from the back pattern of the suede coat.

### 3. JACKET

• Hair-on leather, suede-lined pockets, hair-on facing, horn button.
• Centre back features halved whorl in hide, hair direction follows around the jacket, three-quarter sleeves.

### 4. SMALL HANDBAG

• Hair-on leather, full-grain handles, hair-on strap, bone hardware.
• Cut from the shoulder.

### 5. LOW-HEELED BOOTS

• Hair-on leather, leather insole, wrapped wooden heel, leather

offcuts embedded in rubber soles.
• Cut from the belly.

## 6. LARGE BAG
• Full-grain leather, suede split
and full-grain internal pocket detail,
bone hardware.
• Cut from the shoulder.

## 7. KNEE-HIGH BOOTS
• Full-grain leather, leather insole,
wrapped wooden heel, leather offcuts
embedded in rubber soles.
• Cut from main body and belly.

## 8. PURSE
• Full-grain leather, hair-on leather,
bone hardware, suede interior.

## 9. 2 x BELT BAGS
• Hair-on leather, suede split interior,
full-grain label.

## 10. 2 x CARD HOLDERS
• Hair-on leather, full-grain label.

## 11. 2 x KEY FOBS
• Hair-on leather, full-grain loop.

131

374

LL1308W

# OPENING NIGHT

Malcolm and Annie come to London for the first time in over 20 years for the opening of the exhibit at the V&A. The stresses of the previous week's mad dash to finish the collection dissipate as I see them approach.

I haven't shown them the finished collection yet, so it will be a surprise for them to see it now. From all the hundreds of people who, over the next six months will see the work, it is their opinions I care most about. Since we arrived back in October to collect the hide of Bullock 374, Malcolm had not known what would become of his bullock's hide. Where it went next or whose hands it would eventually reach.

The bresaola created from a joint of silverside was served the previous night to the attendees of a private viewing. I tell Malcolm that I've received an email raving about the taste. Over the course of the last five months I've shared anecdotes like these from delighted customers of his beef.

I felt immense pride in being able to talk about his farm, his produce and his values. This familiarity with him and his farm was invaluable for me in understanding the leather I had made and worked with.

The exhibition, FOOD: Bigger than the Plate, had a purpose:

'Seventy contemporary projects, creative collaborations by artists and designers working with chefs, farmers, scientists and local communities pose questions about how the collective choices we make can lead to a more sustainable, just and delicious food future…'

There were queries about leather's place in that discussion of a food future. As I took friends and family around the exhibit, I overheard people questioning the collection's relevance to the conversation. Leather had always been an ancillary product of our food. What did it have to do with creating a 'more sustainable food future'?

The collection I presented could be received in more than one way: a representation of the animal before the burger or the burger behind the bag.

135

The leather I made has traces of all stages of production – decisions at each point impacted the material that I would work with – the way in which Bullock

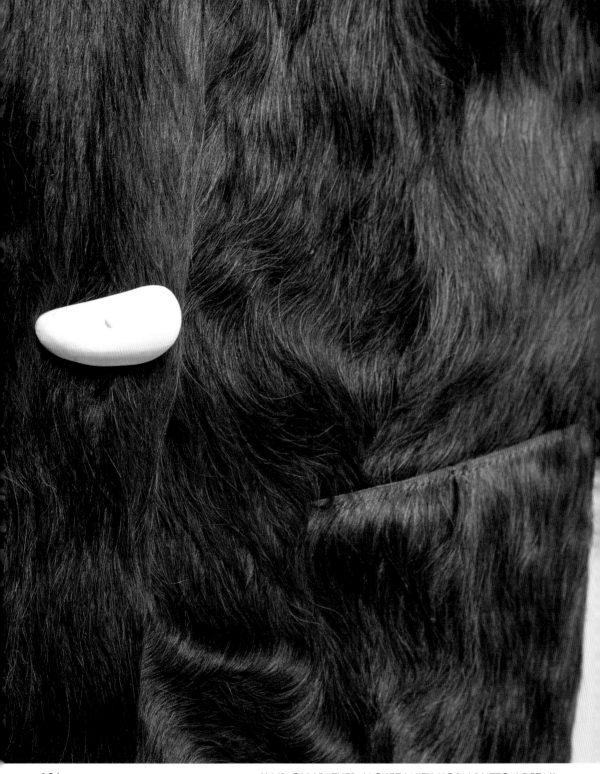

HAIR-ON LEATHER JACKET WITH HORN BUTTON DETAIL

374 was raised and Malcolm's decisions on breed affected the character and size of the hide. At the abattoir, how the hide had been removed impacted the materials later produced. While choices in the tanning and finishing influenced the finished feel and function of the leather.

Beyond this, the materials represented the existence of Charity Farm and the entities required for Malcolm to produce food, which together formed a 'food system'. The material was an emblem of how Bullock 374 had lived and how food had been produced. I now understood that the fibres we wear are inextricably tied to these decisions.

Two things had happened during the time Bullock 374 was in the exhibition. My peers were asking me if I could help them source leather, wishing to know themselves where their materials came from. There was clearly a desire for leather with provenance.

At the same time, farmers who'd seen or heard about the exhibit were offering me their hides, wanting to see all parts of their animals valued.

I had sought to use the understanding of leather's origins in agriculture to inform my design process. This is a connection that has long disappeared in the production and use of leather.

What could the potential be for re-localising the supply chain to rebuild this relationship? Was it possible to create value for raw materials from farming practices that are positive for nature?

What shifts in design approach would be needed?

How can we produce food and materials that tread lightly, repair damage done to the planet and ecosystems, and are fair and equitable for all?

What could this mean for fashion?

The creation of collection 374 had led me to more questions, and now I wanted to go further...

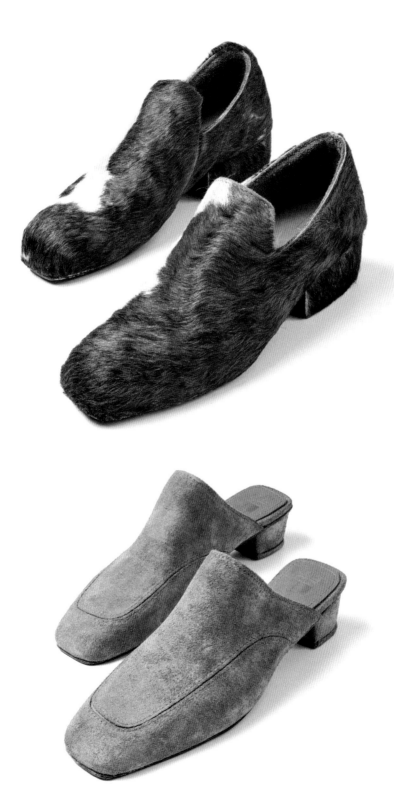

# EPILOGUE
# BRITISH PASTURE LEATHER

**Written with Sara Grady**
**Photographs by Jason Lowe**

## ALICE ROBINSON

I'd met a friend of Sara's at an event on the topic of farming and food, and we had chatted about my work. She suggested that Sara and I speak about our similar interests in leather and agriculture. And although we didn't know it at the time, Sara's call marked the beginning of a new chapter.

Our first conversation lasted around an hour and a half. Sara's aptitude to just pick up the phone and ask questions is a proficiency for which I would later be – many times over – incredibly grateful. In our kitchens, she in France and me in London, we discussed at length where an interest in leather had taken each of us. I was thrilled to speak to someone who shared my curiosity. It was three days before the members of the Victoria & Albert Museum would eat the last cuts of Bullock 374, and soon the exhibit would close.

Both of my collections, Sheep 11458 and Bullock 374, were stories, points of research, commentary meant to inspire new perspectives on materials and design. My initial desire was to better understand fashion's links to farming, but what emerged was the possibility to expand on my experience, taking me much deeper into all the intersections of farming, leather and fashion.

*LEFT TO RIGHT: SARA GRADY AND ALICE ROBINSON INSPECTING SAMPLES OF*
*BRITISH PASTURE LEATHER*

## SARA GRADY

Alice's determination to link her design practice to agriculture required her
to make the extraordinary effort described in this book because leather with
provenance was not otherwise available to fashion designers. But, we had each
wondered, shouldn't that change?

I had arrived at this question myself, just from the other side. For several
years, I was Vice President of Programs at Glynwood, an agricultural
organisation in the Hudson Valley of New York. Glynwood works to
support regional food systems and regenerative farms that deliver
myriad positive impacts.

143

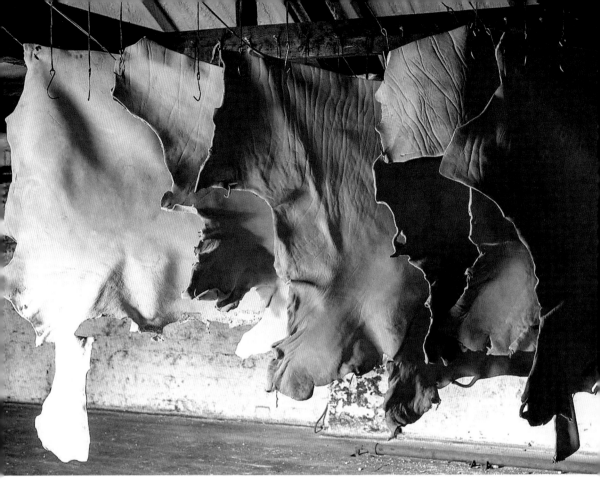

BRITISH PASTURE LEATHER DRYING BEFORE FINAL STAGE OF FINISHING

Glynwood's farm demonstrates the highest standards of regenerative agriculture, which includes raising livestock on pasture. Pastured livestock bring benefits to soil, biodiversity, animals, ecosystems and communities. I believe that if we are raising animals for the healthy food they provide, and doing so with care, then we must meaningfully use all that they yield. But I came to learn how difficult it is for a farmer to know or choose the destiny of the hides from their herd.

Preoccupied with this conundrum, I had made my own attempts to trace a path from farm to finished leather. My experience mirrored what Alice has described in this book – it was only possible if I did it myself.

So when I saw Alice's collection exhibited in FOOD: Bigger than the Plate in 2019, I felt it was a brilliantly concise commentary on the disconnection of leather from its source: farms, land and animals.

We were both asking the same question: 'If we can choose meat from the farming practices we wish to support, why is the same not true for leather?'

Alice and I agreed to work together to make that choice possible – and two years after Bullock 374 was exhibited at the V&A, another exhibition took place:

'Leather from British Pastures', held in London in September 2022, demonstrated our work to create the first supply of leather made from the hides of cattle raised on regenerative farms in the UK. By 2021, building from our early exchange in that first phone call, we had founded our own enterprise called Grady + Robinson. At the time of writing, we are developing what we call British Pasture Leather. Our early samples were used to make the shoes, bags and furniture exhibited in our show.

The goal of the show was to illustrate our ambition: to link leather with exemplary farming and, in so doing, to redefine leather as an agricultural product. It is, however, far from straightforward. Creating new networks and systems involves a great deal of coordination and innovation.

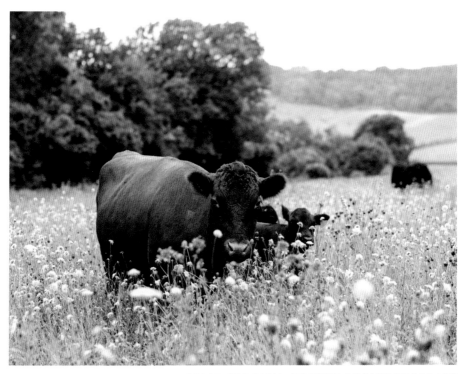

COLSTROPE FARM, CERTIFIED BY PASTURE FOR LIFE

HISTORIC UK TANNERY WHERE BRITISH PASTURE LEATHER IS MADE

ITEMS MADE FOR THE LEATHER FROM BRITISH PASTURES EXHIBIT
TOP LEFT: MULBERRY ALEXA BAG; TOP RIGHT: BILL AMBERG CAMPAIGN CHAIR;
BOTTOM LEFT: CARRÉDUCKER HAND-SEWN OXFORD BOOT;
BOTTOM RIGHT: NEW BALANCE 576 TRAINERS

We begin by working with farms certified by Pasture for Life, an organisation that 'champions the restorative power of grazing animals on pasture' and which comprises a growing network of regenerative farmers. We coordinate with the abattoirs they use, to collect the hides that come from these farms. Our process continues with a traditional vegetable tanning method in a historic British tannery; and concludes in a family-owned finishing facility, using natural methods that celebrate the inherent character of the material, resulting in a biodegradable leather.

Interest in ethical and ecological materials echoes the growing discernment for good meat in our food culture. Designers, brands – and many of us as consumers – are seeking assurance that materials and products have not been destructive, polluting or inhumane in their production or processing.

147

Leather is often criticised, or even rejected, because of the possibility it may be linked to factory farming and associated negative impacts. But, just as all meat is not the same, whether it may be produced industrially or regeneratively, the same is true for leather. A distinction is needed; designers and consumers should have the option to choose leather with a knowledge of the food system and farming practices from which it came.

But, as Alice has chronicled in this book, anyone interested in choosing leather according to values of ecology or animal welfare will likely be frustrated; there has not been an option to source leather by preferencing regenerative farming practices. Until now.

*LEATHER FROM BRITISH PASTURES EXHIBIT BY GRADY + ROBINSON,*
*LONDON DESIGN FESTIVAL 2022*

Our success, however, will depend on a willingness to value the material more than a commodity. With all the complexities of producing British Pasture Leather, our biggest current challenge is reshaping entrenched perceptions of leather. The fashion industry depends on leather being abundant, standardised and cheap. But the leather we are making, with all its positive attributes and emerging from a completely new network of production, cannot be directly compared to, or substituted for, commodity leather. Perceptions of value and quality – along with design approaches – will need to shift to begin to recognise the embedded values of stewarding land and supporting rural economies, animal welfare and biodiversity.

So, as Alice was asked: 'What does leather have to do with creating a more sustainable food future?'

Part of the answer to that question lies in the material's power to evoke a feeling. In Alice's words, leather's 'innate animality' reminds us of our connection to land and ecosystems. It can therefore also be a reminder of our collective responsibility to care for land, animals and nature.

More concretely, if design and material goods can recognise the value of regenerative farming methods that produce food and fibres, these much-needed practices will be more viable, better understood and widely adopted.

## ALICE ROBINSON

My interest in learning about leather's origins in a farming community has led me from the fields of Charity Farm to engaging with a whole network of farmers who are working to restore ecosystems. What began as a simple question has evolved into my belief that fashion and design communities have an obligation to understand, improve and then communicate their links to nature.

It is my hope that Bullock 374 can be seen as a kind of prototype, a gesture towards what is possible on a broader scale: for design industries, especially fashion, to support practices that will look after the land, animals and people that produce food, fibres and materials. For me, creating visibility feels like a promising collective opportunity for new points of storytelling, learning and collaboration.

# REFERENCES

## Introduction: From fashion to field

United Nations Industrial Development Organization, *Future Trends in the Leather and Leather Products Industry and Trade* (2010), Table 4, p.17

United States Department of Agriculture Foreign Agricultural Service, *Livestock and Poultry: World Markets and Trade* (2023) – https://apps.fas.usda.gov/psdonline/circulars/livestock_poultry.pdf

United States Department of Agriculture Foreign Agricultural Service, *US Hides and Skins Exports in 2022* – https://www.fas.usda.gov/data/commodities/hides-skins

http://nothing-to-hide.org/LeatherFacts/Hides_&_skins:_use_or_lose

## Chapter 1: Meeting Malcolm

https://www.globenewswire.com/news-release/2023/02/02/2600667/0/en/Leather-Market-Size-Growing-at-6-2-CAGR-Set-to-Reach-USD-708-7-Billion-By-2030.html#:~:text=LOS%20ANGELES%2C%20Feb.,6.2%25%20from%202022%20to%202030

Cotance, *A new Social and Environmental Report for the European Leather Industry* (2020) – https://www.euroleather.com/news/projects/european-social-environmental-report

Stanley, Pat, *Robert Bakewell and the Longhorn Breed of Cattle* (Farming Press, 1995), pp.49, 53

https://www.thecattlesite.com/breeds/beef/61/english-longhorn/

https://www.longhorncattlesociety.com/the-breed/breed-history

https://leatheruk.org/leather-trade/information/

United Nations Industrial Development Organization, *Future Trends in the Leather and Leather Products Industry and Trade* (2010), p.12

https://www.gov.uk/government/statistics/historical-statistics-notices-on-the-number-of-cattle-sheep-and-pigs-slaughtered-in-the-uk-2022/monthly-uk-statistics-on-cattle-sheep-and-pig-slaughter-and-meat-production-february-2022-published-10-march-2022

UN Food and Agriculture Organization via World Economic Forum, *This is how many animals we eat each year* (2019) – https://www.weforum.org/agenda/2019/02/chart-of-the-day-this-is-how-many-animals-we-eat-each-year/

Leather UK, *FAQs, Where do the raw materials for making leather come from?* – https://leatheruk.org/

http://apha.defra.gov.uk/documents/surveillance/diseases/lddg-pop-report-sheep2021.pdf

https://hedgelink.org.uk/guidance/hedgerow-biodiversity/

https://www.cpre.org.uk/wp-content/uploads/2019/11/CPREZUncertainZHarvest.pdf

https://www.princescountrysidefund.org.uk/wp-content/uploads/2021/06/is-there-a-future-for-the-small-family-farm-in-the-uk-report.pdf

Tilman, David and Williams, David R., *Preserving global biodiversity requires rapid agricultural improvements* – https://royalsociety.org/topics-policy/projects/biodiversity/preserving-global-biodiversity-agricultural-improvements

https://www.chilternsaonb.org/our-landscape/farmland/farmland-habitats-under-threat/

Boatman, Nigel, Parry, Hazel R., Bishop, Julie and Cuthbertson, Andrew, 'Impacts of Agricultural Change on Farmland Biodiversity in the UK', *Issues in Environmental Sciences and Technology* (2007), 25 – https://doi.org/10.1039/9781847557650

https://www.rspb.org.uk/about-the-rspb/about-us/media-centre/press-releases/bgbw-results-23/

https://www.nhm.ac.uk/discover/news/2023/april/almost-half-of-all-uk-bird-species-in-decline.html#:~:text=Farmland%20birds%20have%20shown%20the,below%20their%20number%20in%201970

Hahn Niman, Nicolette, *Defending Beef: The Ecological and Nutritional Case for Meat* (Chelsea Green Publishing, 2021), p.5

*The Cattle Identification Regulations 2007* – https://www.legislation.gov.uk/uksi/2007/529/schedule/3/made

## Chapter 2: Hide

Sustainable Food Trust, *A Good Life and A Good Death: Re-localising farm animal slaughter* (2018), pp.8, 13, 14

Department of Agriculture, Environment and Rural Affairs, *Animal by-products general guidance* – https://www.daera-ni.gov.uk/articles/animal-products-general-guidance

Sustainable Food Trust, *A Good Life and A Good Death: Re-localising farm animal slaughter* (2018), p.17

https://www.voguebusiness.com/sustainability/fur-leather-luxury-poll-peta

https://www.dailymessenger.net/business/news/5873

https://www.hsa.org.uk/faqs/general

*Animal Welfare Act* 2006 – https://www.legislation.gov.uk/ukpga/2006/45/contents

https://www.bradford-hide.co.uk/raw-materials

Parliamentary papers, 1780–1824, Volume 52, Part 2, p.97 – https://www.google.co.uk/books/edition/Parliamentary_Papers/zQNEAQAAMAAJ?hl=en&gbpv=1&dq=flaying+hide+fined+for+damage&pg=PA105&printsec=frontcover

## Chapter 3: A day with John

Sustainable Food Trust, *A Good Life and A Good Death: Re-localising farm animal slaughter* (2018), p.22

Meat Technology Update, *Beef Fat Quality* (1999), p.4 – https://meatupdate.csiro.au/data/MEAT_TECHNOLOGY_UPDATE_99-7.pdf

Sustainable Food Trust, A *Good Life and A Good Death: Re-localising farm animal slaughter* (2018), p.23

https://chiltern-charcuterie.co.uk/

https://www.vam.ac.uk/event/pBqwAQEj/field-fashion-fork-bullock-374

https://www.provenance.org/

## Chapter 4: Hold your breath

Knight, Barry, 'Clayton's Tannery and the Origins in Leather Making', *North East Derbyshire Industrial Archaeology Society* (2003), 11, pp.4–6

Leather UK, *The UK Leather Industry* – https://leatheruk.org/leather-trade/information/

*UK Leather & Leather Goods Industry Report 2021* – https://leatheruk.org/wp-content/uploads/2023/07/LUK-2021-report_web.pdf

European Standards, European CEN standard, EN 15987 – https://www.en-standard.eu/bs-en-15987-2022-leather-terminology-key-definitions-for-the-leather-trade/#:~:text=This%20document%20specifies%20the%20key,test%20methods%20specific%20for%20leather

Dipu Ahmed, M. and Maraz, K. M., 'Benefits and problems of chrome tanning in leather processing: Approach a greener technology in leather industry', *Mater Eng Res* (2021), 3(1): pp.156–164 – https://doi.org/10.25082/MER.2021.01.004

Leather UK, *Industry tannage and end-use* – https://leatheruk.org/leather-trade/information/

http://www.holmes-halls.co.uk/

## Chapter 5: A month of making

https://publications.parliament.uk/pa/cm201719/cmselect/cmenvaud/1952/report-files/195207.htm

Textile Value Chain, *Zero-waste Pattern Cutting* (2020) – https://textilevaluechain.in/in-depth-analysis/articles/textile-articles/zero-waste-pattern-cutting/

# RESOURCES

## BOOKS

Barber, Aja, *Consumed – The Need for Collective Change: Colonialism, Climate Change & Consumerism* (Brazen, 2021)

Burgess, Rebecca with White, Courtney, *Fibershed: Growing a Movement of Farmers, Fashion Activists, and Makers for a New Textile Economy* (Chelsea Green Publishing, 2019)

Fletcher, Kate and Tham, Mathilda, *Earth Logic: Fashion Action Research Plan* (2019) – https://katefletcher.com/

Hahn Niman, Nicolette, *Defending Beef: The Ecological and Nutritional Case for Meat* (Chelsea Green Publishing, 2021)

Klein, Naomi, *No Logo* (Fourth Estate, 2010)

Langford, Sarah, *Rooted: How Regenerative Farming Can Change the World* (Penguin, 2023)

Minney, Safia, *Regenerative Fashion: A Nature-based Approach to Fibres, Livelihoods and Leadership* (Laurence King Publishing, 2022)

Percival, Rob, *The Meat Paradox: Eating, Empathy, and the Future of Meat* (Little, Brown, 2022)

Rebanks, James, *English Pastoral: An Inheritance* (Allen Lane, 2020)

Sustainable Food Trust, *A Good Life and A Good Death, Re-localising farm animal slaughter* (2018) – sustainablefoodtrust. org

Sustainable Food Trust, *Feeding Britain from the Ground Up* (June 2022) – sustainablefoodtrust.org

Thomas, Dana, *Fashionopolis: The Price of Fast Fashion and The Future of Clothes* (Apollo, 2019)

Tree, Isabella, *Wilding: The return of nature to a British farm* (Picador, 2019)

## CONFERENCES

Oxford Real Farming Conference
https://orfc.org.uk/

Groundswell – https://groundswellag.com/

Future Fabrics Expo
https://thesustainableangle.org/future-fabrics-expo-2023/

## ORGANISATIONS

Pasture for Life
https://www.pastureforlife.org/

Textile Exchange
https://textileexchange.org/

Fashion Revolution
https://www.fashionrevolution.org/

# INDEX

# ACKNOWLEDGEMENTS

Since beginning this work I have been incredibly fortunate to learn from industry experts and craftspeople and access generations of knowledge in both the farming and leather industries. Many people that I have had the pleasure of meeting have been tremendously generous with their time and openness, sharing their expertise with me. These interactions have been invaluable, shaping much of the thinking and events within this book. For these reasons, I have many people to thank. With apologies in advance for anyone I may have missed.

Design tutors, academic peers and alumni, who have offered their making expertise, critical thought and collaboration. Tabitha Ringwood, Iliaz Iliazi, Jessica Mason, Richard Suzman, Grannie Walley, Flora McLean, Stephanie Freude, Matt Fowkes, Jessica Pass and Zowie Broach for encouraging your students to ask questions, stay inspired and be hopeful.

Leather industry experts who have generously opened their doors and shared their precious knowledge: David Sherwood, Nick Waudby, Charles Barker, Robert Painter, Jon Loxton, Jonathan Muirhead, Greg Miller, Karl Flowers, Diane Becker, Kerry Senior, the UK Leather Federation and the Worshipful Company of Leathersellers.

Members of the food and farming community for willingly educating me and retaining our connection to farms. Thomas's abattoir, John Roberts, Matthew Parker, Sally Abé. My Uncle Ed for introducing me to Malcolm, and my Uncle Angus for your endless support and for buying two chest freezers. The Chambers family for adopting me into your home during the project, and Catherine Flood and May Rosenthal Sloan for your shared vision in curating FOOD: Bigger than the Plate at the Victoria & Albert Museum, thank you for inviting me to be involved.

Sara Grady and Jason Lowe for our continued collaboration with British Pasture Leather, and the Pasture for Life community of farmers for all I have learned, and hope to learn.

# ABOUT THE AUTHOR

Alice V Robinson's work explores the relationship between food and fashion by connecting farming to the design of products, and revealing the story behind leather. Alice trained as an accessory designer and is an Alumna of the Royal College of Art. Her work has been shown at the London Design Festival, Victoria & Albert Museum and MAD, Brussels; her collection '11458' was acquired by the V&A in 2020.

Alice co-founded Grady + Robinson in 2020 with collaborator Sara Grady, to create British Pasture Leather, the first supply of leather made from the hides of animals raised on regenerative farms in the UK. Inspired by a belief that regenerative agricultural practices are a critical solution in renewing soils, stewarding land and reforming food and fashion systems, Grady + Robinson are linking leather with exemplary agriculture and forging new connections between farming, food and material culture.